FAMILY TREE SHOWING THE CONNECTIONS BETWEEN THE BRITISH, DANISH AND

1840
Queen Victoria = Albert of Saxe-
(1819–1901) Coburg and Gotha
 (1819–1861)

1842
King Christian IX = Louise of Hesse-Cassel
of Denmark (1817–1898)
(1818–1906)

1841
Alexander II =
Tsar of Russia
(1818–1881)

3s, 4d

1858
Victoria, = Frederick III
Princess Royal Emperor of
(1840–1901) Germany (1831–1888)

3s, 1d
Dagmar (Tsarina Marie
Feodorovna) (1847–1928)

1866
= Alexander III
Tsar of Russia
(1845–1894)

1884
Grand Duke = Elizabeth of Hesse
Sergei (1864–1918)
(1857–1905)

2s, 1d

1863
King Edward VII = Alexandra of
(1841–1910) Denmark
 (Queen Alexandra)
 (1844–1925)

1874
Marie = Alfred, Duke of Edinburgh
(1853–1920) and Duke of Saxe-Coburg
 and Gotha
 (1844–1900)

Albert Victor,
Duke of Clarence and
Avondale (1864–1892)

1889
Louise, = 1st Duke of Fife
Princess Royal (1849–1912)
(1867–1931)

1896
Maud = Charles of Denmark
(1869–1938) (King Haakon VII
 of Norway)
 (1872–1957)

Victoria (1868–1935)

1894
Xenia = Grand Duke
(1875–1960) Alexander
 of Russia
 (1866–1933)

1s, 1d

1893
King George V = Mary of Teck
(1865–1936) (Queen Mary)
 (1867–1953)

1894
Nicholas II = Alix of Hesse
Tsar of Russia (Tsarina Alexandra
(1868–1918) Feodorovna
 (1872–1918)

1911
Grand Duke = Natalia
Michael Cheremetevski
(1878–1918) (1880–1952)

King Edward VIII
(1894–1972)

Henry, Duke of Gloucester
(1900–1974)

Olga
(1895–1918)

Tatiana
(1897–1918)

Maria
(1899–1918)

Anastasia
(1901–1918)

Alexis
(1904–1918)

1923
King George VI = Lady Elizabeth Bowes-
(1895–1952) Lyon (Queen Elizabeth,
 The Queen Mother)
 (1900–2002)

1947
Queen Elizabeth II = Philip, Duke of
(b.1926) Edinburgh (b.1921)

Princess Margaret Rose,
Countess of Snowdon
(1930–2002)

Charles, Prince of Wales 2s, 1d
(b.1948)

FABERGÉ'S ANIMALS

A ROYAL FARM IN MINIATURE

Caroline de Guitaut

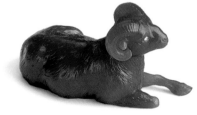

CONTENTS

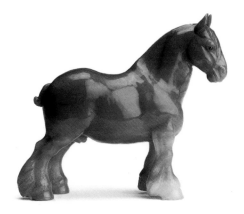

INTRODUCTION

The Royal Collection contains the largest assemblage of works by the Russian goldsmith and jeweller Peter Carl Fabergé (1846-1920) still in Royal ownership. In terms of its size and quality, the collection can only be compared to those formed by Tsar Alexander III and Tsar Nicholas II and their respective consorts Tsarina Marie Feodorovna and Tsarina Alexandra Feodorovna. Unlike the British Royal Collection, these Imperial collections are no longer intact, as they were dispersed in the aftermath of the Russian Revolution in 1917.

The British Royal Collection of Fabergé also gives a remarkable insight into the dynastic relationships between the British, Danish and Russian royal families in the late nineteenth and early twentieth centuries, largely because so many of the pieces now in the collection were given as gifts – to Queen Victoria, King Edward VII and Queen Alexandra, and to King George V and Queen Mary. The most important dynastic link was between the two Danish princesses Dagmar and Alexandra, the daughters of King Christian IX, who married Tsar Alexander III and King Edward VII respectively. In 1885, during the reign of Tsar Alexander III, Fabergé was officially appointed as a Supplier to the Imperial Court and in the same year produced the first of the famous series of fifty Easter Eggs. Introduced to Fabergé by her sister, Queen Alexandra became an enthusiastic patron and Fabergé, who was not only an outstanding craftsman but also an astute businessman, opened his only foreign branch in London in 1903. This became the most profitable branch of the firm, largely due to the patronage of the Queen and other members of the Royal family.

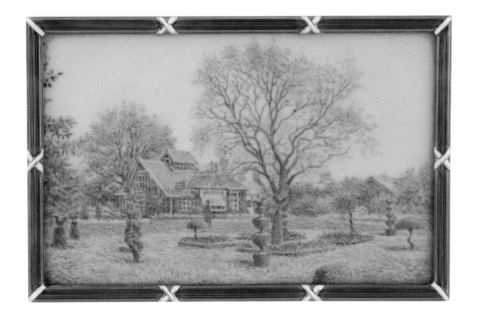

Frame with an enamelled
view of Sandringham Dairy,
4.6 x 7.1 x 2.1 cm;
Fabergé, *c.* 1911.
RCIN 40495

King Edward VII and Queen Alexandra's passion for Fabergé was passed
on to their children, in particular to King George V and his sister Princess
Victoria. King George VI and Queen Elizabeth continued this interest in
Fabergé and themselves acquired numerous items. In all, the collection
numbers well over five hundred pieces, ranging from the Easter Eggs to an
extraordinary collection of twenty-six flower studies, Imperial presentation
boxes, desk accessories, jewellery, bibelots, photograph frames and over two
hundred miniature carved animals of remarkable diversity.

5

FABERGÉ AT SANDRINGHAM

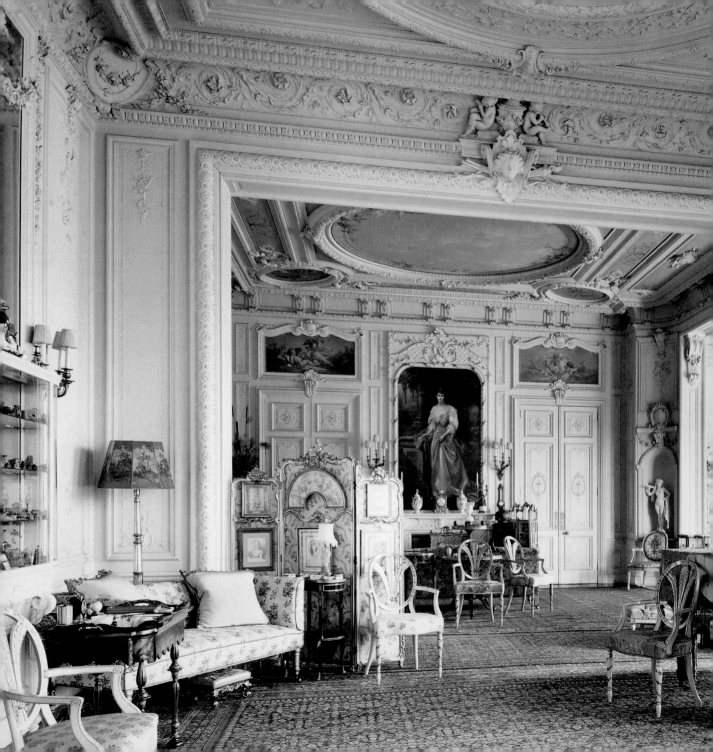

FABERGÉ AT SANDRINGHAM

I never saw anything like them, over 100, and some most beautiful things. The Queen likes most agate animals, of which she has a magnificent collection in two large glass cabinets in the drawing room, which every evening are lit up by electricity.[1]

Viscount Knutsford's account of Queen Alexandra's birthday table on 1 December 1909 at Sandringham House describes the numerous examples of her favourite Fabergé animals. On this occasion alone she received many pieces: King Edward VII gave her the figure of a Chelsea Pensioner (above) and the Prince of Wales (later King George V) presented her with 'a turkey with ruby eyes and a model of her favourite spaniel'. The last two were additions to the extraordinary collection of sculpted animal portraits that King Edward VII had commissioned Carl Fabergé to make in 1907, based on the dogs, horses and farm animals kept on the estate at Sandringham.

The precise circumstances of the Sandringham commission are not fully documented, but it was collectively the largest order ever placed through Fabergé's London branch,[2] and it resulted in the formation of the largest assemblage of Fabergé's Russian hardstone animal sculptures in existence, today part of the Royal Collection. H.C. Bainbridge, manager of the London branch, claimed that the idea for the commission had come to him as a way of meeting the King's and Queen's desire for Fabergé's work, and moreover to satisfy the constant demand from their family and friends who wished to

OPPOSITE:
The Drawing Room, Sandringham House with (extreme left) a display case containing Queen Alexandra's Fabergé collection, 1934.
RCIN 2102384

ABOVE:
Chelsea Pensioner, 11.2 x 4.5 x 2 cm, Fabergé, 1909.
RCIN 40485

Agathon Fabergé (1876–1951), the son
of Carl Fabergé, with H.C. Bainbridge
(right), photographed arranging an
exhibition of Russian art in Belgrave
Square, London, in June 1935.

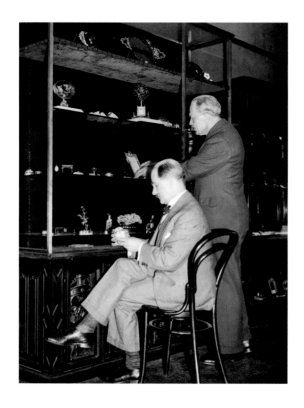

purchase presents from Fabergé for them. Judging
from Bainbridge's account of the London branch,
this difficulty was not restricted to his royal clients.
On the one hand he struggled to obtain enough
stock for the London branch from the overstretched
workshops in St Petersburg and Moscow, and on the
other he was constantly pressed by his clientele with
more and more demands for innovative objects. By
his own admission, Bainbridge was beginning to
find it difficult to suggest new and suitable models
to Fabergé that would appeal particularly to Queen
Alexandra, who like her sister – the widowed
Tsarina Marie Feodorovna of Russia – was one of
the greatest patrons of Fabergé's work. Bainbridge
said, 'the idea came to me to model all the animals
at Sandringham in wax, and have them cut in some
semi-precious stone of the colour of the animal'.[3]
Carl Fabergé evidently agreed that the commission
could be fulfilled. Bainbridge alleged that prior to
this proposal he had talked to Sir Ray Lankester, the
zoologist and then Director of the Natural History
Museum, about the idea of encouraging the breeders of English pedigree
animals to form a fund to have portraits made of their animals in 'stone, silver
or bronze',[4] but nothing had come of the plan. Bainbridge went on to say
that when King Edward VII heard of the proposal to model his animals, he

Frame with an enamelled view of
Sandringham House, 9 x 15.2 x 7.1 cm,
Fabergé, 1908. RCIN 40492

immediately agreed to the idea, and Bainbridge received a telegram stating 'the King agrees, Mr Beck will make all arrangements'.[5] Bainbridge well knew Queen Alexandra's preference for Fabergé's animal carvings, but he was also aware that the King had a liking for Fabergé's creations that rivalled the Queen's. They both paid many visits to the London branch and, according to Bainbridge, new pieces were sent to the Palace for the King to see as soon as they arrived from Russia.

LEFT: Frame with a photograph of
Queen Alexandra when Princess of Wales,
11.8 x 11.9 x 0.5 cm, Fabergé, 1898. RCIN 38808

RIGHT: Frame with a photograph of
Edward VII when Prince of Wales,
3.3 x 3.5 x 3.6 cm, Fabergé, c. 1896. RCIN 40237

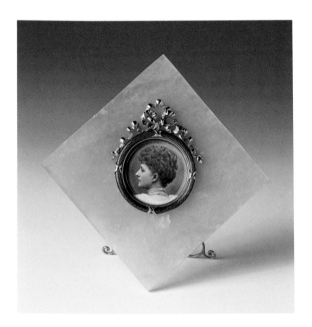

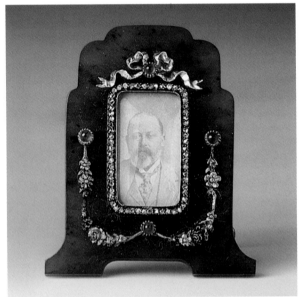

Queen Alexandra's taste was for the more modest of Fabergé's pieces, partic-
ularly animals and flowers. She rarely purchased jewellery from the London
branch, and the small number of pieces she did purchase were given away as
presents. She was more interested in the intrinsic charm of Fabergé's objects
and the quality of the craftsmanship. It was known in the circle of the King
and Queen that those wishing to purchase a present for them should avoid
expensive objects, which might make the recipient uncomfortable and even

Queen Alexandra when Princess of Wales,
on horseback at Sandringham with the
Prince of Wales, *c.*1865. RCIN 2933127

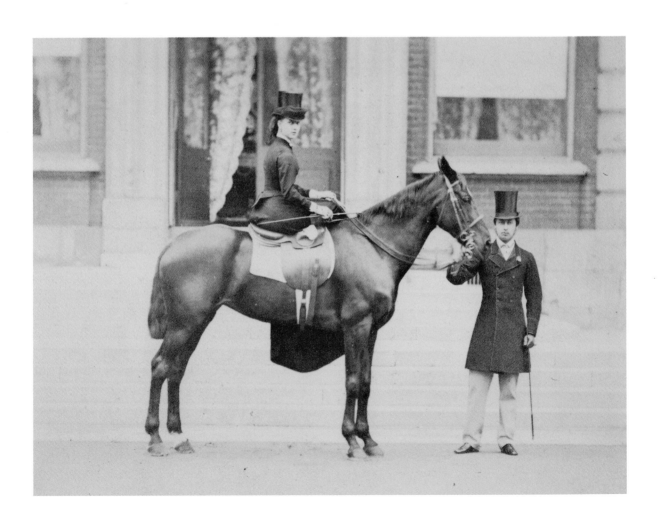

The interior of Fabergé's
New Bond Street branch, *c.*1911.

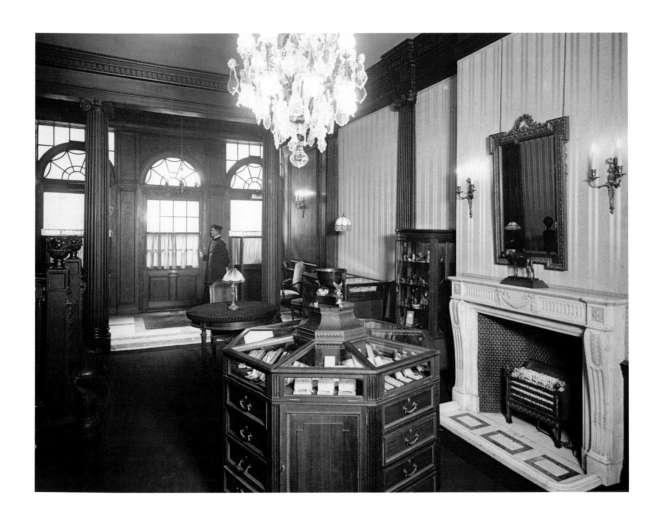

cause offence. It seems that the Hon. Mrs George Keppel, the King's favourite mistress, may have had a role in putting the idea for the commission to the King; not only was she an aficionado of Fabergé, but she was well acquainted with the Queen's collection. Bainbridge claims that it was she who put the idea directly to the King.

It has been suggested that there was no specific commission at all – that the portraits came about in a haphazard manner and that photographs of the favourite horses, dogs and other animals were sent to Bainbridge for Fabergé to use as a guide for his hardstone carvers. This view may be discounted because there is clear evidence that Fabergé sent his sculptors to Sandringham, where they stayed for several weeks making portraits in wax – it is hard to believe that Fabergé would have sent his finest sculptors all the way from St Petersburg to Norfolk if the commission were not of a significant nature. What is more, the London ledgers reveal an increased level of purchasing of animals during 1908–10, corresponding with the period when the wax models were translated into hardstone carvings and sent to the London branch.

As soon as Bainbridge had news of the King's approval for the commission, he took the next train to Wolferton and was met by the royal brougham, which took him straight to Sandringham. There he met the King's land agent, Mr

Frank Beck, who showed him a list from the King. Not only were the King's famous racehorse Persimmon, his shooting pony and all Queen Alexandra's dogs to be modelled, but also one of almost every kind of animal he possessed – cows, bulls, heifers and even pigs were to be included. Bainbridge seems to have been taken aback by the extent of the commission and recalled, 'I left Wolverton (*sic*) Station that night with an uneasy feeling that I had bitten off far more than I could chew.'[6] Bainbridge began to worry about sourcing enough of the right stones of just the right colour with just the right markings. In reality these considerations were much more the concern of Fabergé himself, and of his sculptors and hardstone carvers in St Petersburg. The King was adamant that there should be no duplicates among Queen Alexandra's collection of Fabergé animals,[7] and it was therefore important that each model should be unique and carved from an appropriate stone.

The commission must have been somewhat daunting for Fabergé. He sent over at least two of his best animal sculptors, who were based on the estate for several months. There are no records of the precise length of their stay, where they were lodged or how they were paid. Bainbridge undoubtedly played a major role in the administrative details. It must be assumed that with the destruction at their own request of the private papers of both King Edward VII and Queen Alexandra, some interesting references to the commission were lost. However, from various sources a picture emerges.

Two of Fabergé's sculptors were central to the success of the project; these were Frank Lutiger and Boris Frödman-Cluzel. Lutiger was of Swiss origin

and was attached to the London branch. Bainbridge
reported that Lutiger joined the other sculptors sent
from St Petersburg to work at Sandringham and that
he later worked on sculpting Leopold de Rothschild's
animals at Ascott in Buckinghamshire. The second of
the sculptors sent from Russia was Boris Frödman-
Cluzel (*b*.1878), who was of Swedish and French
parentage. He had trained at the Baron Stieglitz
School in St Petersburg, where he spent three years
from 1894, and he continued his education at the
Royal Academy of Fine Arts in Stockholm. His
association with Fabergé began between 1903
and 1906, and he was regarded as an exceptionally
talented sculptor. A review of an art exhibition held

in St Petersburg in September 1907 records: 'his figures of dogs and bulls,
as well as people … are equally alive'.[8] He had experience of sculpting
horses for Fabergé, including some for the Pavlovsky regiment of guards.
Two months later the sculptor was already in London, according to a
letter dated 15 November 1907 to his friend Olga Bazankur. He reported
that he had been summoned to work for the King and that he would be
engaged for at least two months. On 24 December he wrote to her again,
this time on writing paper from Sandringham House. He explained with
great excitement that his client was King Edward VII, that he was living in a
'hall' on the estate and that he was working well under the personal super-
vision and praise of his client, who had supplied him with a list of animals

Pekingese in fluorspar.
See p. 53 for details.

A shooting party at
Sandringham, November
1908. RCIN 2303428.a

to be sculpted – presumably the list that Mr Beck had given to Bainbridge.
'My zoological range has been added to by twenty new models that I have
made here,'[9] he continued. This last statement seems to imply that he had
moved on from the more familiar territory of horses and dogs and had begun
to model some of the farm animals. He went on to say, 'but what is most
precious to me is that praise which is generously splashed on me by this
amiable and rare king! Queen Alexandra has invited me here for the
second time, I've already been to London after having lived here more than
a fortnight.' An article in the St Petersburg Bulletins, dated 20 December
1907, gives further details, explaining that Frödman-Cluzel had been
warmly welcomed by both the King and the Queen and that he and the
other sculptors had been treated as guests of honour and even invited for a
day's shooting with the King. Among the people Boris Frödman-Cluzel met

at Sandringham were the Kings of Norway and Spain, the Emperor of Germany and George, Prince of Wales, 'for whom he worked just as conscientiously as he did for his father'. He had planned to return to St Petersburg in January 1908, but was still in England in February that year owing to the high level of commissions from Fabergé, including modelling horses and dogs for Leopold de Rothschild. Alfred Pocock, an English sculptor and gem-cutter, may also have been involved in the commission. He worked as an independent artist but had also, from time to time, worked for the London branch of Fabergé. One sculpture of a dog is consistently ascribed to him: the Pekingese in fluorspar (see p. 53 and above), and Bainbridge claims that Pocock also modelled a donkey (see p. 76).

Previously unpublished evidence shows that others from the Fabergé firm were present at Sandringham at this time. The Visitors' Book from the land agent's residence reveals the signatures of several Russian names including Zuegitse'ev, a naval lieutenant, and a Frejdman-Kluzen – tantalizingly similar to Frödman-Cluzel. But most significantly among the land agent's papers is a letter from Nicholas Fabergé, Carl Fabergé's youngest son. Dated 31 December 1907, it describes 'the happiest and most enjoyable X-mas holidays I've had since I left my country 5 years ago'.[10] This letter was addressed to Frank Beck's eldest daughter Meg (*b.*1892), with whom Nicholas Fabergé

had fallen in love – unfortunately his love was unrequited. He had evidently spent some time during the Christmas period on the Sandringham estate which, importantly, coincided with the work that was being undertaken by Fabergé's sculptors. Nicholas had become joint manager of the London branch with H.C. Bainbridge following its move to 48 Dover Street in 1906, and his presence at Sandringham during those weeks cannot have been a coincidence.

The most important moment came when it was time for King Edward VII to inspect the wax models of all the animals that the sculptors had prepared. These were assembled in Queen Alexandra's Dairy. According to Bainbridge, this event took place on 8 December 1907, seven days after Queen Alexandra's birthday. It had apparently been the King's intention to present at least some of the animals to the Queen for her birthday that year. In his diary entry for 1 December 1907, the Prince of Wales (later King George V) writes, 'mother-dear's birthday (63) we all went up to the house at 10.45 to wish Motherdear joy and give her her presents, she has some lovely ones, mostly Russian animals'.[11] These did not of course include any of the animals now identified as forming part of the commission, and it seems that the King's enlargement of the plan had completely changed the timing of the project. Accompanied by his guests and by his favourite dog, Caesar, who was 'rushing in and out and barking all the time', King Edward VII made his way after lunch to the Dairy, where the sculptors had been working and where they waited anxiously for his approval of their labours. Bainbridge described how he waited nervously until the King's equerry, the Hon. John Ward, told him 'the King would like

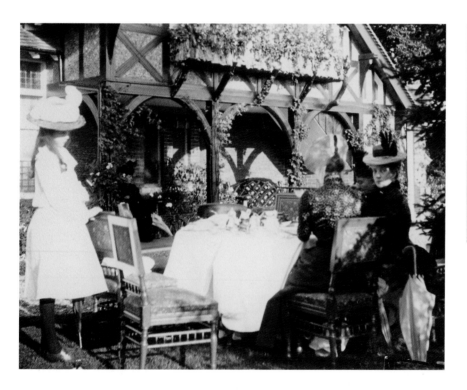

to see you'. The King apparently emerged from the Dairy and said, 'Will you
please tell Mr Fabergé how pleased I am with all he has done for me. I have
pointed out to the artists one or two places where some little alterations can
be made, but otherwise I think the work splendid.'[12]

21

With this seal of approval, Bainbridge was free to arrange for the delicate wax models to be sent to St Petersburg for the stone-carvers and workmasters to begin production. The exceptions were the model of the racehorse Persimmon, which was sent to the Moscow silver workshops to be cast as the legs were too fragile to be cut in stone, and the model of the dog Vassilka, which was also cast in the Moscow workshops. A photograph of Fabergé's design room in his St Petersburg headquarters (p. 25) shows a number of wax models in cupboards in the background. None of the wax models survives in

the Royal Collection, and there are no other Fabergé wax models known to be in existence. This photograph therefore provides a valuable record of how the wax models would have appeared.

The models were then passed to the 'sculptor-stonecarvers', as Fabergé's designer François Birbaum referred to them.[13] Those who carved the models were probably Kremlev (or Kremlyov) and Derbyshev. Prior to 1908, stone-carving was of secondary interest to the Fabergé firm. Objects of semi-precious Siberian and other kinds of stone were used as subjects for settings, as a background for gold, silver and enamel work. A number of small hardstone objects were produced, together with some larger objects such as decorative vases, clocks, inkstands and lamps. At this time almost all stonework was cut and carved at the Woerffel works in St Petersburg and the Stern works in Oberstein (Germany) rather than in Fabergé's own domain. However, Fabergé's ever-increasing use of stone, and the fact that the orders had to be executed without the normal supervision of Fabergé's exacting craftsmen, compelled the firm to open its own stone-carving workshop. As a result the work could be directly supervised and the cutting of the stone co-ordinated with the subsequent jewellery and gold-chasing work. Kremlev was invited to manage the Fabergé stone workshop. He had graduated from the Ekaterinburg Art School and as well as managing this part of Fabergé's business he made many of the works himself. Derbyshev had also studied at Ekaterinburg; a very talented artist and stone-carver, he later moved to Paris and worked for Lalique.[14] As stone became an ever-increasing part of the firm's production, the qualities and beauty of the vast variety of naturally

occurring Russian hardstones encouraged Fabergé's designers to bring them to the forefront of the firm's output. This chiefly manifested itself in the increased production of figures, flowers and animals, and it is here that the Sandringham commission fits into the development of Fabergé's firm.

The selection of the correct stone to emulate the colouring and markings of a particular animal or bird was of paramount importance to Fabergé's sculptors. Hence Dexter bulls are depicted with shiny black coats, pigs with soft pink skin tinged with brown and hens with brown feathers speckled with a grey sheen. There are occasional departures from realism – for example the green bulldogs. The carefully observed poses and intricately carved details, with every feather, hair, claw, paw and hoof described, set Fabergé's models far apart from those produced by his contemporaries and competitors, including Cartier. Moreover, the sculptures of known animal portraits – Caesar, Persimmon, Vassilka and many others – seem to capture the true personality of these creatures, a quality that only sculptures modelled from life could possess. The range of stones used in the animal portraits includes those which Fabergé particularly favoured: agate, chalcedony, obsidian, jasper, purpurine and bowenite. (See glossary of hardstones, p. 116.)

Once the hardstone carving was completed, the carvings were returned to the workshop of the head workmaster. In 1908 this was Henrik Wigström (1862–1923), the third and final head workmaster of the firm. At this point the carvings were polished and fitted with the gold parts needed, such as feet for the studies of birds. The gem-set eyes and any enamelled gold elements

Design Room, Fabergé's headquarters,
St Petersburg, c. 1910.
A selection of wax models for hardstone
carvings is visible in the cabinet
at the back of the room.

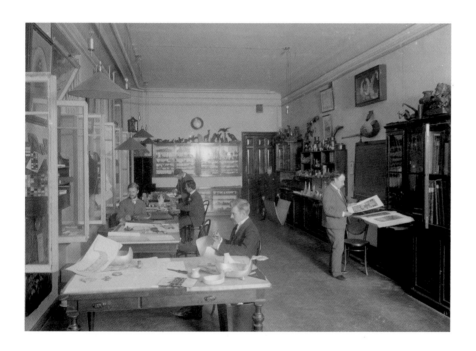

were also added – for example Caesar's collar (see p. 39). Although a small proportion of the design albums from Wigström's workshop have survived,[15] surprisingly few drawings relate to animal sculptures, given that the majority of the animals from the Sandringham commission were finished in Wigström's workshop. The one exception is a drawing of the goose (p. 92). Perhaps the reason for this is not merely that the books are now lost. The explanation may be that the commission was a private undertaking for a royal client, similar

in character to the private commissioning of Easter Eggs for the Russian Imperial family.

Once completed, the models were sent to Fabergé's London branch, where they were purchased over a number of years by the King, the Queen, members of the royal family and their friends. It is impossible to be precise about the scope of the commission and the exact number of portrait models it entailed. Eighty-four are included here, selected on the basis of known portraits, date of production, breeds native to East Anglia and examples of animals known to have inhabited the estate at Sandringham, together with the records of purchases made through the London branch. It is thought that approximately one third of the two hundred Fabergé animals in the Royal Collection formed part of the commission. Not all the portrait sculptures remain in the collection today. Between June and July 1912 Queen Alexandra purchased a model of Sandringham Dido from Fabergé's London branch in white magnesite with two rubies (for the eyes) at a cost of £36. Sandringham Dido was a smooth-haired Basset hound that had won Best of Breed at Crufts in 1907. It has not proved possible to identify this model among the portrait models now in the Royal Collection. The dog was further immortalised by Fabergé in a silver bas-relief set in a nephrite frame with a silver-gilt rim, which was purchased by Mrs George Keppel from the London branch in December 1913 for the price of £22. An obsidian shire horse that belonged to the Duke of Gloucester (1900–74) was included in a sale at Christie's in 1954, where it is recorded as having been modelled from life at Sandringham.

The overall cost of the commission is likewise difficult to calculate. It has been suggested that a gap in the ledgers of Fabergé's London branch (between October 1906 and October 1907) coincided with the commission, and that a sum noted in the ledgers for 14 October 1907 of £5240 5s 3d for 'Purchases to St Petersburg. Note 49. Cost of goods sold in London to date' refers to the cost of the commission. However, given the evidence of the dates when the sculptors started work, and taking into account the time it would have taken to send the completed wax models to St Petersburg for translating into hardstone and to have them sent back to London, this suggestion now appears unlikely.

In summary, it is easy to see why the Sandringham commission came about – Queen Alexandra's love of Fabergé's work was well established by this date[16] and her love of his animal carvings was well known, not least by the King. The King and Queen shared a passion for animals – whether dogs or horses – particularly those connected with their life at Sandringham, the 3,000-hectare estate that King Edward VII, as Prince of Wales, had purchased in 1863. After its purchase the house was remodelled and the Prince set about creating a model farm and establishing the famous Royal Stud. Sandringham became the favourite country home of King Edward and Queen Alexandra and their children, where they would invariably spend their birthdays (9 November and 1 December), Christmas and the months of January and February.

The King took a close personal interest in all aspects of the running of the estate, particularly the Home Farm, the shoot and the Royal Stud and stables.

Princesses Louise, Victoria and Maud
with a carriage and ponies at the main
entrance to Sandringham House, 1882.
RCIN 2104066

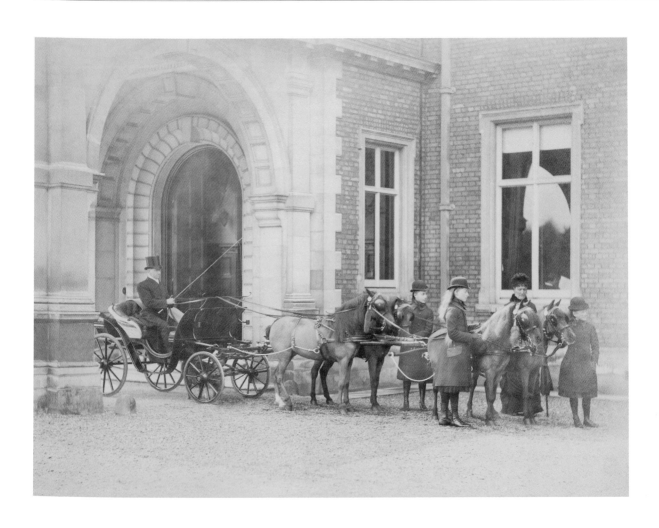

His interest in farm livestock was passed on to his son, King George V, who noted in his diary on 9 December 1907, 'Papa and I went to Smithfield for the Fat Cattle show. I got a 2nd prize with my pigs.'[17] The Queen would spend her time with her children, riding around the estate in her horse-drawn carriage or skating, and she also took a close interest in the extensive gardens that were established there. She was much concerned, as was the King, with the welfare of all the estate workers and their children. She established a school on the estate for the training of local boys in arts and crafts,[18] and every year on her birthday she held a tea party for children of the surrounding villages, the menu for which included milk produced by the Sandringham herd and prepared in her Dairy.[19] Queen Alexandra's Dairy was to be found in the immediate grounds of the house and had been the scene of the famous viewing of the Fabergé wax models by the King. As well as being a functioning dairy, it was here that she entertained guests to tea (see illustration on p. 21). Sandringham must have been a welcome contrast to official life in London; as if to underline the difference the clocks there were set half an hour ahead of Greenwich Mean Time. This may have been because of the Queen's notorious unpunctuality; life in Norfolk moved at a different pace in more senses than one.

Not far away from the main house, in the twenty-six kennels, a huge assortment of dogs was kept, all of which the Queen knew individually and regularly fed with cubes of bread. These ranged through Borzois, Great Danes, bulldogs, Japanese spaniels, dachshunds, pugs, terriers, Chinese chows, Pomeranians and Basset hounds as well as the working dogs – Labradors

and Clumber spaniels. The more unusual breeds included a Samoyed, Jacko, from an Arctic expedition and a Siberian sledge dog known as Luska. As Queen Alexandra's Private Secretary recalled in a letter, 'The Queen is such a regular Dog-worshipper that Her Majesty likes all dogs – Dogs of any breed or description.'[20] The Queen was also a great horse lover – there are many photographs recording her pony Viva and her pony and trap, along with those of her children both in the house and around the estate. The King was also an animal lover and, like the Queen, was fond of his pet dogs – particularly his terrier Caesar, who accompanied him everywhere. The King took great interest in arrangements for the many house guests during the shooting season. During such weekends, the Sunday ritual was always the same: after church and luncheon, all guests were conducted on a lengthy tour of the stables, kennels, gardens, model farm, stud farm and Queen Alexandra's school.

From memoirs and biographies and from sources in the Royal Archives, a picture of the great house parties held at Sandringham may be built up. For example, among the guests for dinner on the occasion of Queen Alexandra's birthday in 1907 (the birthday with which King Edward VII's commission of Sandringham animals has been linked) were the following: the King and Queen of Norway, the Prince and Princess of Wales, Princess Victoria, the Duke and Duchess of Buccleuch, His Excellency the Portuguese Minister (Marquis de Soveral), the Norwegian Minister (Doctor Hansen), the Earl and Countess de Grey, Lord and Lady Farquhar, the Hon. Reginald Lister and the Hon. Charlotte Knollys. Many of these were among the best customers of

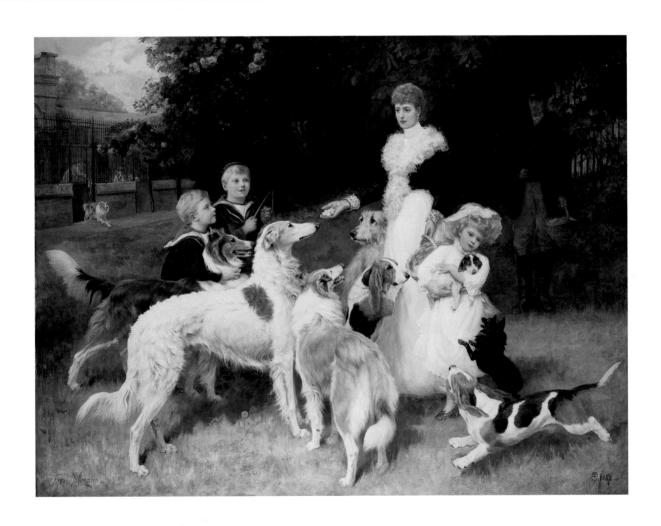

Frame with a miniature
of Tsarina Marie Feodorovna,
9 x 7.8 x 7.3 cm,
Fabergé, c.1895.
RCIN 40107

Fabergé's London branch – together with the King's friends and contemporaries such as Stanislas Poklewski-Koziell, Leopold de Rothschild, Sir Ernest Cassel, Lord Revelstoke and the Duke of Norfolk.

The addition of the Sandringham animals to Queen Alexandra's collection of Fabergé animals was of great significance in the formation of the royal collection of Fabergé. It may be seen as part of a desire to commemorate people and places, and was clearly related to the King's and Queen's fondness for Sandringham. In terms of works by Fabergé in the Royal Collection, the animals are joined by many photographs and miniatures in enamelled and jewelled frames that were given as presents by members of the English, Russian and Danish royal families at this date. Sculpted portraits of family members were also exchanged, such as the cameo of Edward, Prince of Wales (later King Edward VIII), and the portrait bust of Tsar Alexander III, husband of Marie Feodorovna. There are numerous Fabergé boxes and frames in the Royal Collection that record views of the royal residences, some of which were commissioned by the royal family. Fabergé made boxes and frames for both Russian and English clients.[21] By the extension of his work to mementoes of royal pets and other animals we are provided with a unique snapshot of Edwardian royal life. The idea of having animals immortalised in Fabergé's hardstones became popular with other of his clients in London, including Mrs Leopold de Rothschild – who had a silver model made of her husband's racehorse St Frusquin, which Persimmon had beaten into second place in the Derby. There were many instances of similar works supplied through Fabergé's headquarters in St Petersburg. For example, Birbaum

32

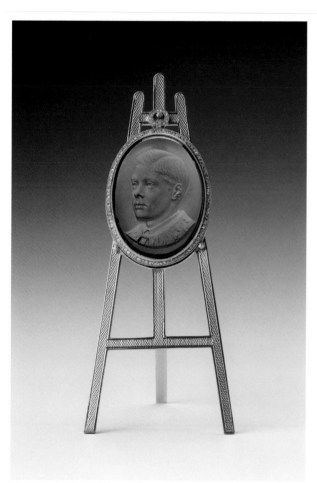

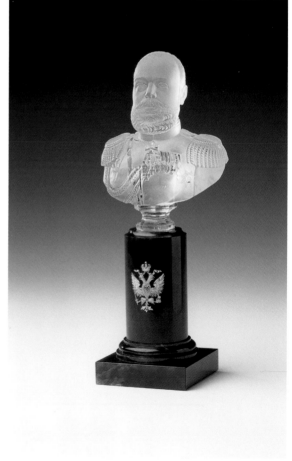

makes reference to the 'famous French bulldog belonging to the actress
Balletta'.[22] Moreover, Queen Alexandra's sister, Tsarina Marie Feodorovna,
owned many animal sculptures, of which some were undoubtedly portrait
models. According to an inventory of the possessions of Marie Feodorovna
and Alexander III, compiled after 1917 by the chief director of the Anichkov
Palace, more than one hundred stone animals were listed.[23] She purchased
many Fabergé animals, but once the London branch had opened it was less
easy for her to find unique presents for her sister. In 1906, Marie Feodorovna
wrote to Queen Alexandra: 'Now that silly Fabergé has his shop in London,
you have everything, and I can't send anything new, so I'm furious.'[24]

After King Edward VII's death in 1910, Queen Alexandra continued to live at Sandringham House (until her own death in 1925), surrounded in the Drawing Room by her remarkable collection of Fabergé animals in two glass display cabinets that were lit every evening by electricity.

1 Sydney Holland, Viscount Knutsford, *Black and White*, p. 238

2 Fabergé's London branch opened in 1903 and closed in 1915.

3 H.C. Bainbridge, *Twice Seven*, p. 199

4 op. cit., p. 199

5 op. cit., p. 199. Frank Beck was the land agent at Sandringham from 1891 to 1916, when he was lost at Gallipoli during the First World War. He was succeeded by his brother Arthur, who was land agent until 1937.

6 op. cit., p. 200

7 op. cit., p. 197

8 Pushkin House, Archive 15, inventory 1, file 668

9 ibid., sheet 15

10 Courtesy of Mr Graham Beck

11 RA/GV/GVD: 1 December 1907

12 H.C. Bainbridge, *Twice Seven*, pp. 201–2

13 Habsburg & Lopato 1993, p. 451

14 Habsburg & Lopato 1993, p. 460

15 Tillander-Godenhielm, *et al*, 2000

16 De Guitaut 2003, pp. 14–16

17 GV/GVD: 9 December 1907

18 W.A. Dutt, *The King's Homeland*, p. 127

19 RA/MRH/MRHF/MENUS/MAIN/SHM/1 December 1904

20 RA/VIC/Add A 21/228/115

21 A music box with views of the Yusopov palace in St Petersburg was made in 1907; Bainbridge refers to boxes made with enamel views of Chatsworth and Knole.

22 Habsburg & Lopato 1993, p. 457

23 Muntian 1997, p. 330

24 Tsarina Marie Feodorovna to Queen Alexandra, 18 December 1906, Hoover Institution, Stanford, quoted in Ulstrop, *House of Romanov and House of Fabergé*, p. 186

Wherever a silhouette is illustrated, it represents the carving at actual size.

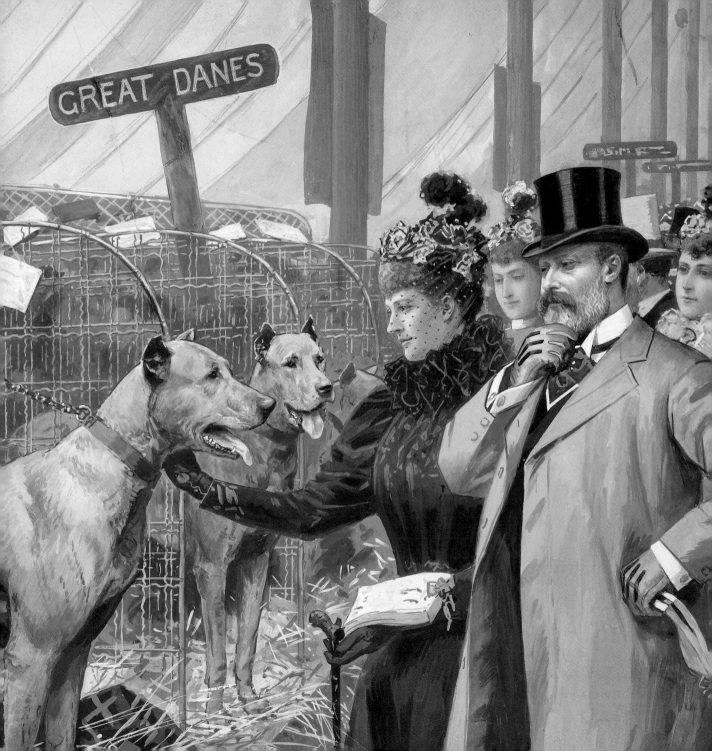

GREAT DANES

DOGS AND CATS

CAESAR

c. 1908

PREVIOUS PAGE:
Edward VII and Queen Alexandra
at a dog show, watercolour, 1905
RCIN 921082

The Norfolk terrier Caesar was bred by the Duchess of Newcastle about 1895 and presented to King Edward VII soon after his favourite Irish terrier, Jack, had died in 1903. Caesar quickly became the King's favourite dog and accompanied him everywhere, often travelling abroad to France and Germany. On a visit to Marienbad in August 1907, Caesar was taken ill and Sir Frederick Ponsonby, the Keeper of the Privy Purse, recalled how he tried to persuade the King against the idea of sending for Sewell, a vet from London, at a cost of £200 per day, 'but His Majesty said that if his dog was ill he would get the very best man and he did not care what it cost'. In the event Caesar was cured by a vet from Vienna.

Fabergé's model in chalcedony with cabochon ruby eyes hints at the dog's mischievous personality and also his faithfulness to his master – adorned as it is with a gold and enamelled collar inscribed 'I belong to the King', as the favourite's collar had been in real life. According to Bainbridge, Caesar accompanied the King on 8 December 1907 as he unveiled the animals modelled in wax by Fabergé's sculptors in the Dairy at Sandringham, where his

King Edward VII with Caesar, 1908.
RCIN 2107402

Chalcedony, gold, enamel, rubies
5.9 x 8.4 x 3.3 cm
RCIN 40339

own likeness was among those on view. After the King's death on 6 May 1910 Caesar wandered the corridors of Buckingham Palace in search of his master. A portrait of Caesar at the time, painted by Maud Earl and entitled *Silent Sorrow*, was reproduced in the *Illustrated London News* on 21 May 1910. In June 1910 a publication supposedly written by Caesar himself was issued, entitled *Where's Master*. It sold over 100,000 copies. Caesar's final duty was to walk behind the King's coffin, led by a Highlander, in the funeral procession from Westminster to Paddington on 20 May 1910. Caesar died in 1914 and is buried in the grounds of Marlborough House. A carving of him in marble sits at the feet of the King on his tomb in St George's Chapel, Windsor.

Caesar's grave in the grounds of Marlborough House, London.
RCIN 11955

39

VASSILKA

1908

Queen Alexandra when Princess of Wales, with Alex, one of her Borzois, 1890s.
RCIN 2106287

Vassilka the Russian wolf-hound or Borzoi had been presented as a pair with Alex as a gift from Tsar Alexander III and Tsarina Marie Feodorovna to King Edward VII and Queen Alexandra and were probably the first examples of their breed to be represented in the Sandringham kennels. A further pair, Molodetz and Oudalska, was later given to King Edward VII. Queen Alexandra became well known for her Borzois, which she bred and showed. She was often photographed with them, as this elegant portrait taken in the 1890s testifies. Vassilka won the prize for best dog at the Norwich Kennel Club Show and won second and third prizes at Manchester in 1903, when eleven months old. In total throughout his life he won more than seventy-five prizes and achieved Champion status. This portrait is very finely modelled. Vassilka and Persimmon are the only animal portraits from the Sandringham commission to have been executed in silver and produced in Fabergé's Moscow workshops. Vassilka was purchased from Fabergé's London branch by the Earl Howe (Lord-in-Waiting) at a cost of £32 5s 0d (described as 'Borzoi Hound Bassilka silver gl on orletz base').

Silver, aventurine quartz
13.4 x 21.1 x 9 cm
Moscow silver marks of 91 zolotniks (1908–17)
C. Fabergé in Cyrillic characters
English import marks for 1908
RCIN 40800

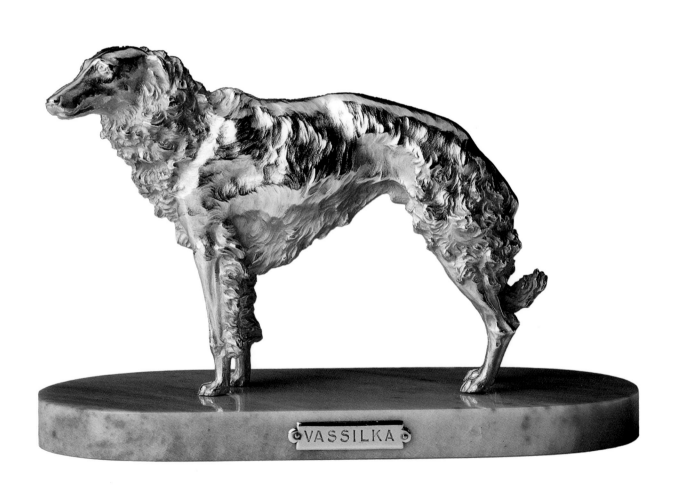

VASSILKA

SANDRINGHAM LUCY

*c.*1908

Chalcedony, rubies
4.4 x 10.5 x 3.6 cm
RCIN 40442

Like his father, the Prince of Wales (later King George V) was a keen field sportsman and kept many gun dogs at Sandringham, some of which were shown at local dog shows. These dogs were kept in the kennels at Wolferton on the Sandringham estate and remained there after King Edward VII's death, from which time the Sandringham kennels continued under the guidance of Queen Alexandra until her death in 1925.

King George V was particularly keen on Labrador retrievers and Clumber spaniels for his working dogs, and Sandringham Lucy was a very fine example of the latter. The portrait model is both well observed and particularly endearing, and was purchased by King George V, when Prince of Wales, in 1909 at a cost of £102.

ABOVE LEFT:
The future King George V with a
Clumber spaniel, *c.*1895.
RCIN 2108189

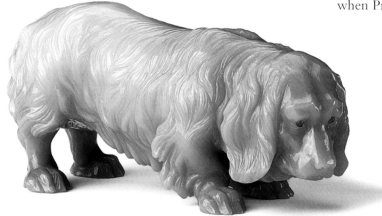

Fabergé's sculptors have chosen this piece of agate care-fully to represent the long-haired coat of the Borzoi and its distinctive colouring – the pale translucent stone represents the white coat of the dog and the brown its characteristic markings. The painting of Queen Alexandra surrounded by her dogs and grandchildren at Sandringham kennels (p. 31), made in 1902 by Frederick Morgan and Thomas Blinks (the latter painted the dogs), shows some of Her Majesty's Borzois.

LABRADOR RETRIEVER

c. 1907

LEFT: Chalcedony, rose diamonds
3.7 x 3.5 x 1.8 cm
RCIN 40026

RIGHT: Variegated agate, rose diamonds
6.6 x 6.7 x 3 cm
RCIN 40443

Both King Edward VII and the Prince of Wales kept Labrador retrievers in the kennels at Sandringham as working dogs. Sandringham was known at the time of the commission as a great sporting estate, and shooting was the centrepiece of the house parties given by King Edward VII, a tradition that continued in the reign of King George V. All the dogs were registered with the Kennel Club.

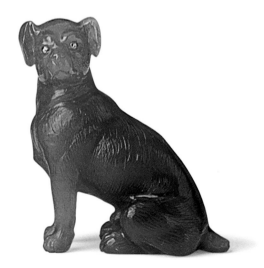
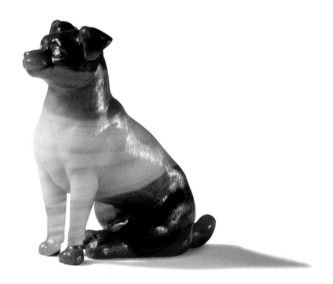

DACHSHUND AND DACHSHUND PUPPY

*c.*1907

Among the remarkable variety of breeds kept in the kennels at Sandringham by King Edward VII and Queen Alexandra, the dachshund was well represented. W.A. Dutt refers to 'the rare and valuable rough-haired Bassets – dogs of the dachshund type of which the Sandringham kennels possess examples not to be beaten anywhere'. Queen Victoria was the first British monarch to be particularly fond of dachshunds. From the 1840s onwards she had brought over from Coburg many examples of the breed, some of which became her favourite pets. The dachshunds were successfully bred in the Sandringham kennels, as this adult and puppy possibly indicate. In 1908 Grand Duke Michael purchased from Fabergé's London branch for £14 10s 0d a dog described as 'Dashund (Basset Dog) calcedy'. In addition, in 1912 Queen Alexandra purchased a sculpture of Sandringham Dido ('Dog, white magnesite, 2 rubies, "Sandrg Dido" £36'), a smooth-haired Basset hound which had won Best of Breed at Crufts in 1907. It is not possible to identify her purchase among the portrait sculptures now in the Royal Collection.

PUPPY
Agate, rose diamonds
1.8 x 4.3 x 1 cm
RCIN 40059

DACHSHUND
Agate, rose diamonds
4.3 x 7.3 x 2.1 cm
RCIN 40392

CAIRN TERRIER

c.1907

Agate, rose diamonds
4.5 x 6 x 1.8 cm
RCIN 40047

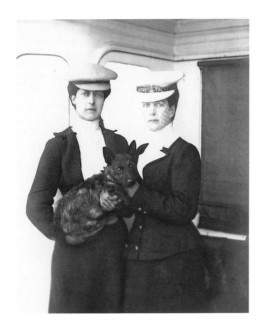

Queen Alexandra and Princess Victoria of Wales with the Princess's terrier Mac, on board HM yacht *Victoria and Albert*, 1904. RCIN 2928262

Cairn terriers were owned by both King George V and his sister Princess Victoria. Princess Victoria's terrier, Mac, was a lively example of the breed and travelled with her, even on board the Royal Yacht *Victoria and Albert*. King George V owned numerous terriers, including Happy, a cross-breed acquired in 1904. Much later the King owned two Cairn terriers, Snip and, finally, Bob, who outlived his master. This charming portrait model is most likely to be one of the favourite royal pets of either the Prince of Wales or Princess Victoria. In 1908 Queen Alexandra purchased a number of Sandringham animals from Fabergé's London branch, including a 'Welsh Terrier Dog, in agate' at a cost of £14 10s 0d. Later the Marquis de Soveral, a Portuguese diplomat and friend of King Edward VII and Queen Alexandra, purchased a 'dog, scotch terrier of brown agate' for £17 10s 0d.

In 1899 Major Frederick. G. Jackson presented the Princess of Wales (later Queen Alexandra) with Jacko, a Samoyed. Major Jackson had been leader of the Jackson–Harmsworth Expedition to Franz Josef Land in the Arctic between 1895 and 1898. This characterful portrait in chalcedony with rose diamond eyes almost certainly represents the famous dog.

LEFT: In July 1903 Edward VII was photographed with a Samoyed in several different poses.
RCIN 2107216

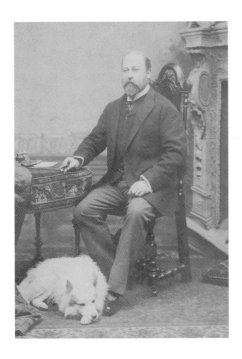

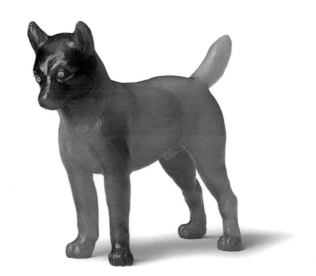

PUG

*c.*1907

Agate, rose diamonds

5 x 4.7 x 2 cm

RCIN 40046

Previously thought to be a model of a griffon, this well-observed portrait has features that seem closer to those of one of the many pugs in royal ownership at the time of the commission, some of which were housed in the Sandringham kennels. Queen Alexandra was photographed with a pug and a collie as Princess of Wales in the 1890s. As Prince of Wales, King George V also owned pugs, and 'black pugs' are recorded as being residents of the Sandringham kennels.

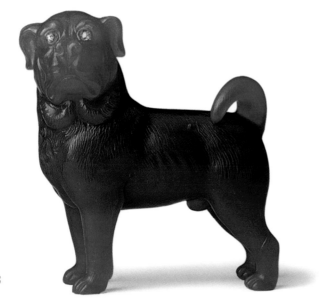

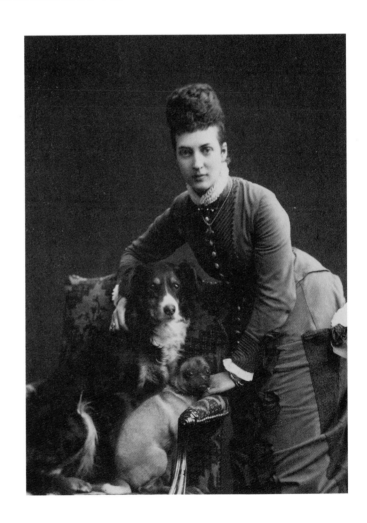

PEKINGESE

*c.*1907

Agate, rose diamonds

3.6 x 4.4 x 1.9 cm

RCIN 40390

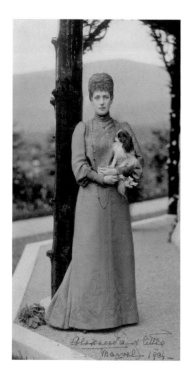

Queen Alexandra with
Little Marvel in 1904.
RCIN 2106334

Queen Alexandra was particularly fond of small breeds such as Pekingese, Japanese Chins (known as Japanese spaniels at the time), Tibetan spaniels and papillons. These small dogs seemed to accompany her wherever she went, travelling to the different royal residences and also accompanying her abroad. In April 1905 Queen Alexandra received a gift of four pairs of Pekingese dogs from the Empress of Japan, but during the long and arduous journey all but one of the dogs died. Two of her favourites were called Little Marvel and Little Togo, and were contemporaries. In 1904 she was photographed with Marvel and in 1905 with Togo. There are numerous other photographic portraits of the Queen with both dogs. This charming carving perfectly captures the endearing personality of the breed with its characteristic long, soft coat, black and white markings and expressive fluffy tail. In 1909 Fabergé's London ledgers reveal that the Duc d'Elchinger purchased a model of a Japanese spaniel called Togo in white chalcedony with two rubies for a cost of £29. Although it was clearly not this model, the fact that it was given a name in the ledger entry seems to indicate that it was a portrait carving.

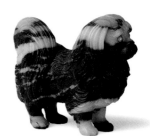

POODLE

Both Princess Victoria and the Prince of Wales (later King George V) owned poodles. Princess Victoria's poodle was called Sammy, and he was photographed on numerous occasions by the Princess herself. A page from one of the Princess's albums of 1895 shows Sammy with the Princess of Wales in the kennels at Sandringham. The variegated agate used by Fabergé's stone-carver provides a striking portrait, but no trace may be found in the London ledgers of the purchase of this distinctive dog and it is unclear whether it was intended as a portrait of Sammy. The Prince of Wales also owned a French poodle, named Bobeche.

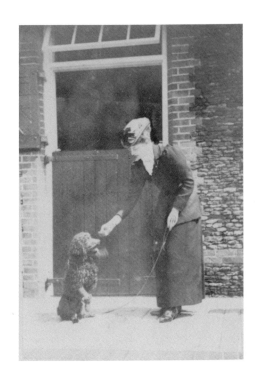

Queen Alexandra when Princess of Wales with Sammy at the Sandringham kennels, 1895. RCIN 2924755

QUEEN ALEXANDRA'S PEKINGESE

*c.*1907

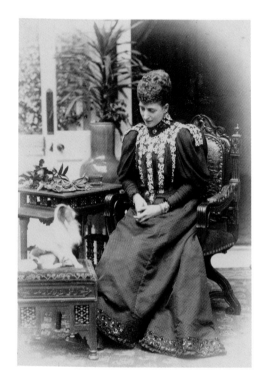

Queen Alexandra with one
of her beloved Pekingese, *c.*1895.
RCIN 2106288

Since the first listing of the collection of Fabergé animals at Sandringham was made, this model has always been referred to as 'Queen Alexandra's Pekingese'. In fact the precise identity of the breed is not easy to determine – it may be a Pekingese but could also be a Japanese Chin. In addition to Little Togo and Little Marvel, Queen Alexandra's faithful companions Facie and Punchie are buried in the grounds of Sandringham House. Unusually, this portrait is carved from fluorspar – a stone not usually associated with Fabergé's hardstone models. The sculpting of the dog has been credited to Alfred Pocock, an English modeller and sculptor who produced animal carvings independently but also worked for Fabergé's London branch. Bainbridge asserts that Pocock was one of the sculptors who worked at Sandringham in 1907 alongside Boris Frödman-Cluzel and Frank Lutiger. He adds that in 1905 or 1906 Queen Alexandra had asked to see models for two animals and that it had been necessary for Fabergé to find a modeller in London at short notice. Pocock, a scholarship pupil at

Fluorspar, rose diamonds
11.4 x 6 x 12 cm
RCIN 40268

the Royal Academy Schools, was selected and apparently produced the models to the Queen's satisfaction. It is easy to see why this model would have appealed to the Queen, given her love of this particular breed, but it is difficult to be certain that this is a specific portrait model. In the Cartier Archives a drawing exists for a similar dog, albeit in a smaller version with cabochon sapphire eyes. However, Bainbridge records that it was modelled at Sandringham and cut in St Petersburg.

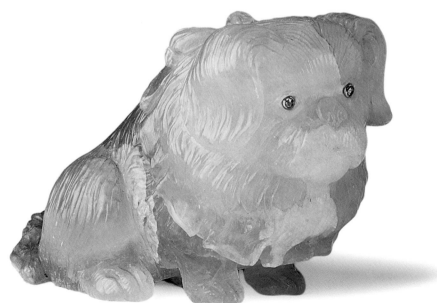

BULLDOGS

*c.*1907

The models of bulldogs are of a type repeated by Fabergé's craftsmen and were therefore obviously popular with his clientele. The translucent, pale green bowenite is combined with rubies or olivines for eyes and gem-set gold collars that also bear tags with various inscriptions, including '1st Prize' (in Cyrillic characters or in French). A further example, this time standing, is carved from aventurine quartz. They are clearly not portrait models, but numerous examples were purchased at this time from the London branch. There are seven bulldogs in various hardstones – including bowenite, nephrite and obsidian – in the Royal Collection, many of which are very similar in size, style and pose.

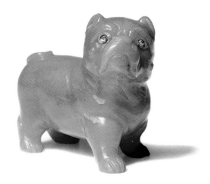
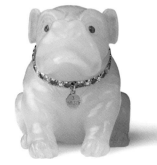
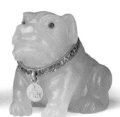

FRENCH BULLDOG

*c.*1910

This expressive carving of a French bulldog was purchased by King George V on 7 November 1910 and was almost certainly modelled from life at Sandringham. It is on a much larger scale than the majority of the animal carvings and is enhanced with a gold and enamelled collar and gold bell. Its scale clearly dictated the higher-than-average price paid for it – £38. When Prince of Wales, the King owned a French bulldog named Paul. He was kept at Sandringham and was a prize-winning example of the breed.

BOTTOM LEFT: King Edward VII pictured with Paul *c.*1902.
RCIN 2107220

BELOW: Agate, guilloché enamel, gold, rose diamonds
9.8 x 13 x 6.1 cm
RCIN 40008

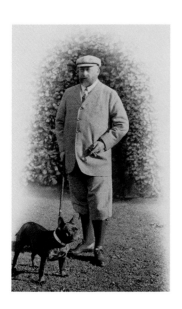

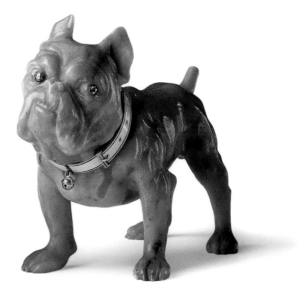

55

SEATED FRENCH BULLDOG AND BULLDOG

*c.*1907

LEFT: Bowenite, olivines
4.1 x 4.9 x 3.8 cm
RCIN 40430

RIGHT: Bowenite,
rose diamonds, gold
4.2 x 5 x 3.6 cm
RCIN 40408

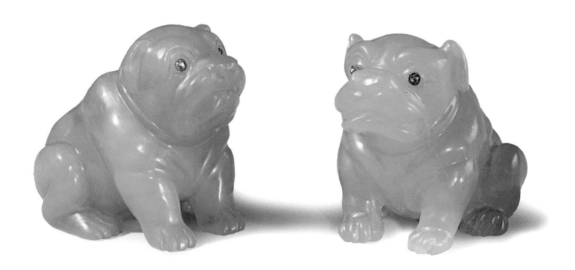

The Border terrier was among the many breeds kept in the kennels at Sandringham. The playful character of the breed is carefully captured by Fabergé's sculptors, and, with the model on the right, the chalcedony has been particularly selected to emulate the dog's colouring.

The portrait on the left of a Border terrier is of brown agate with rose diamond eyes.

LEFT: Agate, rose diamonds
3.1 x 5 x 1.9 cm
RCIN 40042

RIGHT: Chalcedony, rose diamonds
3.1 x 4.9 x 2.3 cm
RCIN 40444

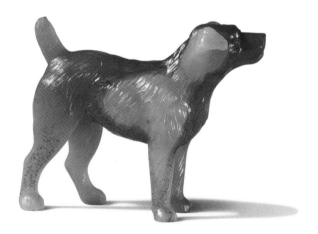

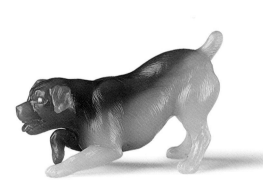

CAT

Jasper, olivines, gold
5.6 x 5 x 1.9 cm
RCIN 40294

Christmas card from Tsarina Alexandra Feodorovna to the Prince of Wales, 1900, with a photograph of her three eldest daughters, one of whom is stroking a toy cat. RCIN 2926938

This acutely observed portrait of a cat arching its back may have been purchased by King George V.

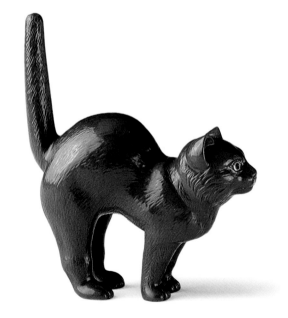

Agate, rose diamonds
2.7 x 5 x 2.3 cm
RCIN 40037

KITTEN

c.1907

Of agate with rose diamond eyes, this portrait of a kitten at play was modelled from life at Sandringham, where Fabergé's sculptors would have come across many such animals. Queen Alexandra was photographed several times with cats. In July 1908 Queen Alexandra purchased a 'group of two kittens, grey chalcedony, gold saucer, white opq en' at a cost of £52 10s 0d. In 1911 she bought another kitten, described as 'kitten agate 2 rubies', for £15. Several other models of cats were sold through the London branch, but the precise provenance of this model is not known.

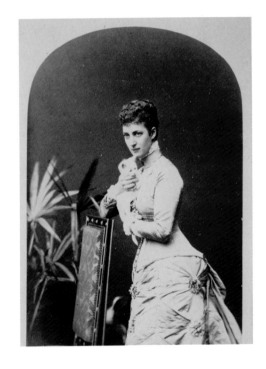

Queen Alexandra when Princess of Wales, photographed holding a kitten, 1882.
RCIN 2106219

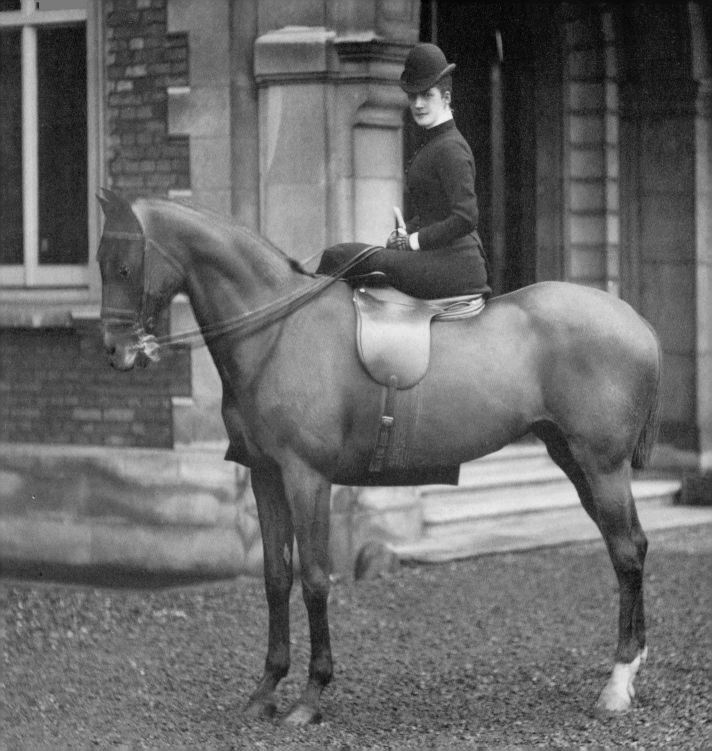

HORSES

PERSIMMON

1908

PREVIOUS PAGE:
Queen Alexandra riding
side-saddle on 'Viva', 1905.
RCIN 2106243

Persimmon was King Edward VII's most successful race-horse. He was the winner of the Derby and St Leger in 1896 and of the Ascot Gold Cup and Eclipse Stakes in 1897. His is one of the only two of the Sandringham animal models made in silver. The model was made by Boris Frödman-Cluzel and the statuette by Henrik Wigström in 1908. Frödman-Cluzel was fascinated by the horse as a breed, and in his letters from June 1907 to his friend Olga Bazankur he refers to his work for the Pavlovsky Guards Regiment: 'I was to sculpt an equestrian statuette and they [the regiment] have offered me a marvellous model in one of the cavalry regiments'. King Edward VII purchased the model of Persimmon from the London branch in November 1908 at a cost of £135. A month later, on 21 December, the King bought six bronze copies of the model at a cost of £63. These were clearly designed to be given away as mementoes, perhaps to the trainers and others who had contributed to the horse's remarkable success. One example is now in the Hodges family collection in New Orleans. The idea of immortalising racehorses in Fabergé's metalwork or silver caught on – Leopold de Rothschild's St Frusquin, which Persimmon had beaten into second place in the Derby, was also modelled in silver by Fabergé (purchased by Mrs Leopold de Rothschild in December 1912) and two bronze copies were ordered through the

Silver, nephrite
24.3 x 31.2 x 9.6 cm
Mark of Henrik Wigström;
silver mark of 91 zolotniks (1908–17)
FABERGÉ in Roman letters, English import marks for 1908
RCIN 32392

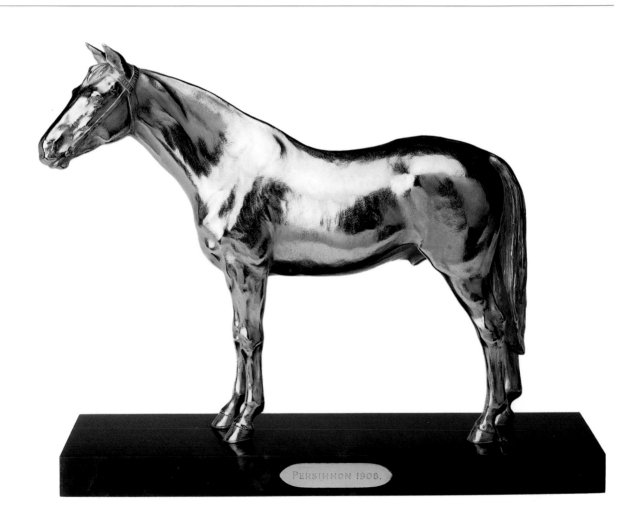

PERSIMMON 1908.

Frame with a photograph of Persimmon,
Fabergé, c.1908, 12 x 15.8 x 10.1 cm.
RCIN 15168

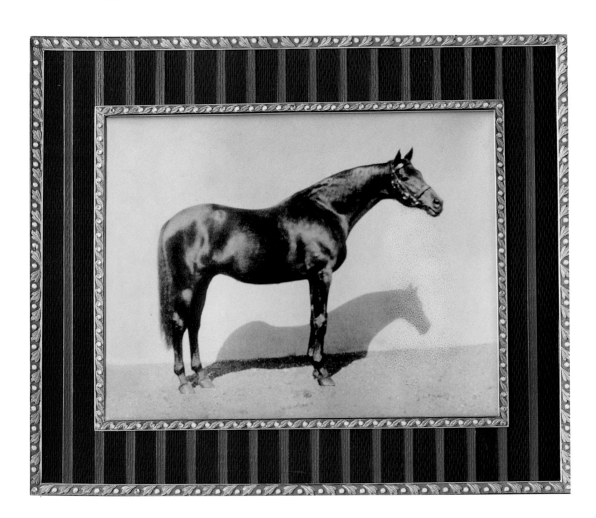

London branch in December 1913 at a cost of £15 each. A frame in the King's racing colours was made by Fabergé, and contains a photograph of Persimmon. It was purchased by Queen Alexandra from the London branch at a cost of £70, but the date of purchase is unknown. The production of frames and other items in racing colours became popular too, and a number of items were made in yellow and blue, representing Leopold de Rothschild's colours. Fabergé's silver statuette of Persimmon was modelled right at the end of the horse's life; on 10 January 1908 he slipped and broke his pelvis, and he died on 18 February. The Prince of Wales, later King George V, described the event in his diary: 'Poor Persimmon died at Sandringham on Tuesday, a terrible loss, one of the finest horses in the world.'

Extract from the diary of George, Duke of York (later George V) for June 1896, describing Persimmon's victory at the Derby.

IRON DUKE

*c.*1907

King Edward VII when Prince of Wales
on Iron Duke, 1900.
RCIN 2107340

Iron Duke was King Edward VII's shooting pony. He was modelled from life at Sandringham and translated into an aventurine quartz sculpture mounted on a nephrite base with a plaque inscribed with his name. Queen Alexandra purchased this sculpture from the London branch in December 1909 for the price of £70, presumably as a Christmas present for the King.

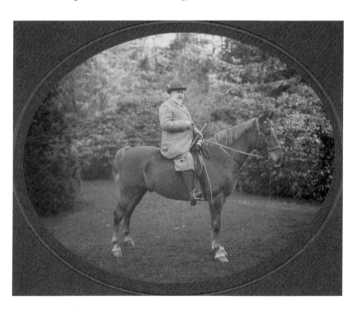

Aventurine quartz, cabochon sapphires, nephrite, silver-gilt
10.5 x 13.8 x 5.4 cm
RCIN 40411

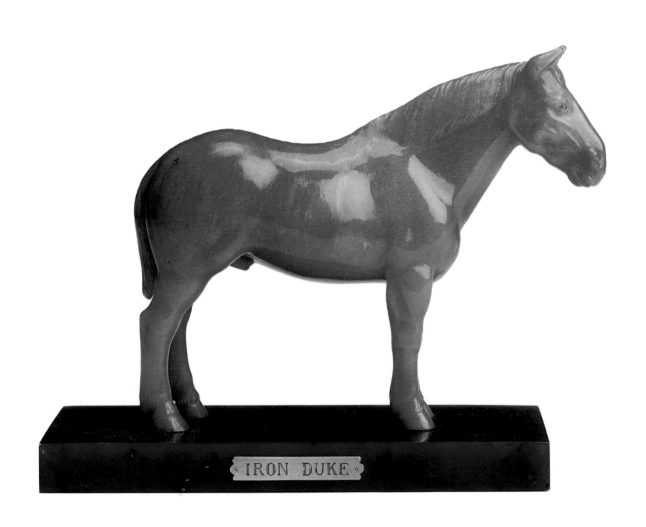

IRON DUKE.

FIELD MARSHAL

*c.*1907

Aventurine quartz, cabochon sapphires
14.5 × 17 × 5.7 cm
RCIN 40412

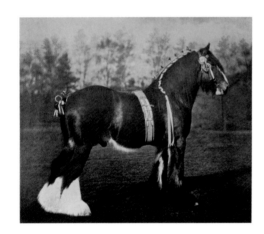

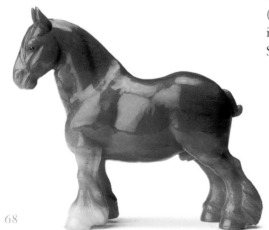

Working horses were kept on the estate at Sandringham, and there were several champions among them at this date, shown locally and regionally. There is no record in the London ledgers of a horse sculpture entitled Field Marshal, which is the name of the horse this model has been traditionally thought to represent. However, a Shire stallion model named Hoe Forest King was purchased from Fabergé's London branch on 27 June 1909 by Queen Alexandra – described as the King's Shire stallion in the ledger and made of brown orletz, it may be this very model, particularly as its price (£73) would seem to indicate an expensive and therefore larger model. A further Shire horse, made of obsidian, had belonged to the Duke of Gloucester (1900–74) but was sold at Christie's in 1954, where it was described as having been modelled from life at Sandringham. Field Marshal V, a descendant of the original horse, was bred by King George V and was champion at the Shire Horse Society Show in 1920 and 1921.

ABOVE LEFT: A photograph of Field Marshal V in 1920.
RCIN 502135

SHIRE HORSES

*c.*1907

There are two further Fabergé models of Shire horses in the Royal Collection. Both are on a much smaller scale, one of dark brown agate with rose diamond eyes and the other of chalcedony with rose diamond eyes.

LEFT: Agate, rose diamonds
5.5 x 6 x 2.5 cm
RCIN 40441

RIGHT: Chalcedony,
rose diamonds
5.5 x 6 x 2.5 cm
RCIN 40456

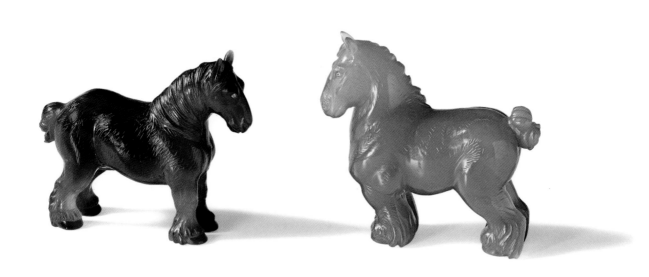

THE FARMYARD

JERSEY BULL

c. 1907

Chalcedony, cabochon rubies

3.8 x 6.2 x 3.1 cm

RCIN 40043

PREVIOUS PAGE: The Prince and Princess of Wales at St Columb's Agricultural Show, 9th June 1907. RCIN 2303437

Carved from chalcedony with cabochon ruby eyes, this is probably an example of a Jersey bull from the herd kept on the Sandringham estate. The active pose in particular suggests that this sculpture was among those modelled from life in Norfolk. As Prince of Wales, King Edward VII took a keen interest in the livestock kept on the estate, even attending sales of his Shire horses, cattle and Southdown sheep at Wolferton. He often required his house-party guests to attend auctions at the Home Farm.

Among the herds of cattle kept by King Edward VII at Sandringham were pedigree shorthorns, red polls, Jerseys and Irish Dexters. The herd was reputed to be one of the finest in England and won many prizes. These animals were mainly kept at Church Farm, Wolferton, and continued to be bred by King George V. This magnificent carving is made of obsidian, a natural volcanic glass which when highly polished has a velvety sheen, particularly suited to replicating the shiny quality of the coat of a well-groomed bull. This model was purchased by Queen Alexandra from the London branch in November 1908 for £44.

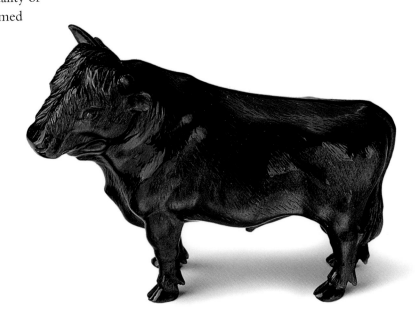

COW

*c.*1907

Bowenite, cabochon rubies

4.2 x 6.7 x 2.8 cm

RCIN 40455

This charming model has a naturally observed pose but, unusually, is made not in a suitably selected naturalistic coloured stone, but in bowenite, a stone regularly used by Fabergé for decorative and functional objects, set with cabochon ruby eyes.

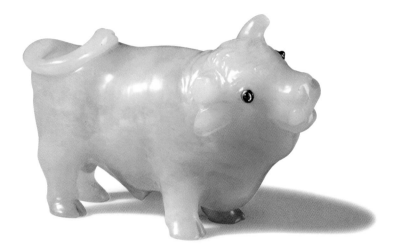

Agate, rose diamonds

4 x 7.1 x 3.6 cm

RCIN 40017

Several breeds of sheep were to be found on the estate at Sandringham during King Edward VII's time. The Southdown was particularly well represented and this ram is thought to represent the breed. It is, perhaps surprisingly, the only model of a sheep by Fabergé in the Royal Collection.

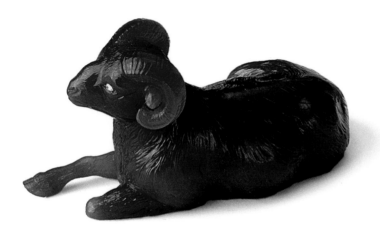

DONKEY

c. 1907

Chalcedony, rose diamonds
2.6 x 3.3 x 1.2 cm
RCIN 40033

Invoice dated 7 November 1910.
RA/GU/PP3/128/

According to contemporary accounts, an Italian donkey was kept at Sandringham around 1900 and was used by the young princes and princesses to draw a carriage. This is possibly the donkey which Marie Feodorovna, Queen Alexandra's sister, is feeding in the photograph (right), taken in the Mews at Sandringham during her visit in 1907. This carving of chalcedony is thought to be the donkey purchased by King George V from the London branch on 7 November 1910 at a cost of £11 5s.

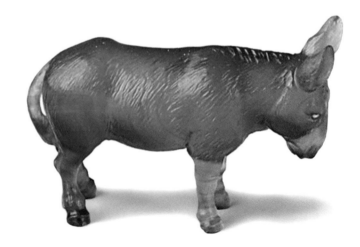

Tsarina Marie Feodorovna with a donkey
at Sandringham, 1907.
RCIN 2925677.a

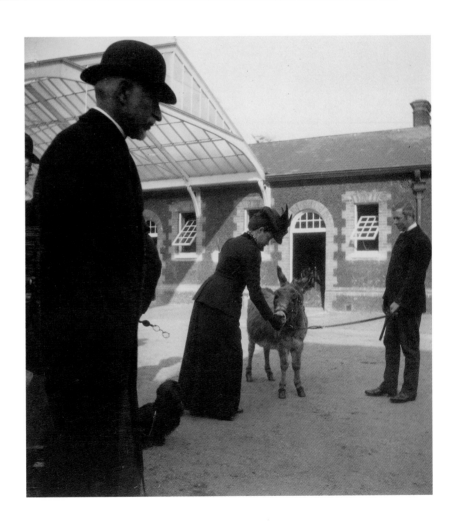

LARGE WHITE SOW

c. 1907

Aventurine quartz, rose diamonds
7.2 x 14.7 x 7.5 cm
RCIN 40041

The recumbent pose of this sow was acutely observed from life by one of the team of sculptors working at Sandringham. Pigs were surprisingly popular examples of Fabergé's animal sculptures – Marie Feodorovna had several examples among her large collection of Fabergé models, and many were purchased from Fabergé's London branch by Queen Alexandra, King George V, Queen Mary and Princess Victoria. This particular sculpture belonged to Princess Victoria, who had purchased a pig from Fabergé's London branch on 25 November 1912 at a cost of £14 10s. It was later exhibited at the exhibition of Russian art in Belgrave Square, London, in 1935.

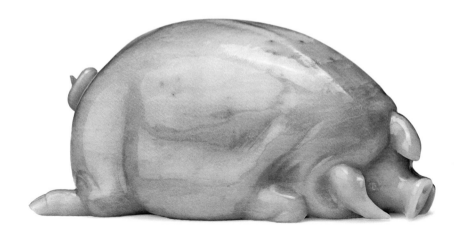

Modelled from life at Sandringham, this charming study in aventurine quartz with rose diamond eyes is particularly evocative. King Edward VII had no hesitation in taking any house guest willing to show an interest in the pigsties at the Home Farm to admire the Norfolks. On one such visit the King of Greece admired the 'improved Norfolks', only to find he was instantly presented with a boar and a sow. Those were sent to the Hellenes, together with a stockman from Sandringham to give instruction on how the breed should be reared.

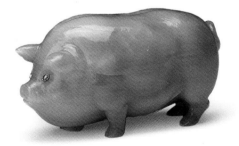

Agate, olivines
2.6 x 4.3 x 1.9 cm
RCIN 40424

Chalcedony, rubies
3 x 4.9 x 1.8 cm
RCIN 40006

Agate, rose diamonds
3 x 7.4 x 4.7 cm
RCIN 40421

Chalcedony, olivines
3 x 4.5 x 1.6 cm
RCIN 40012

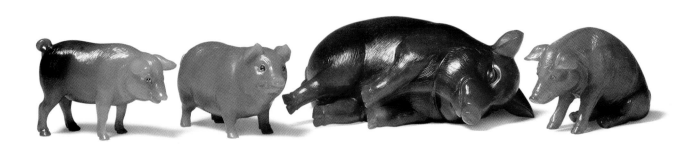

LEFT TO RIGHT:
Aventurine quartz, rubies
3.5 x 5.5 x 2.6 cm
RCIN 40422

Agate, olivines
3 x 7 x 2.8 cm
RCIN 40423

Agate, rose diamonds
2.1 x 4.4 x 1.6 cm
RCIN 40011

Agate, rose diamonds
3.5 x 4.7 x 2.1 cm
RCIN 40015

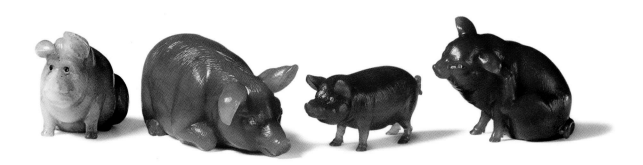

PIG

c. 1907

Aventurine quartz, rose diamonds
9.4 x 9.6 x 7.3 cm
RCIN 40001

Fabergé's sculptors produced a wide variety of pigs in different poses, keenly observed from life. The wax models were then translated into carefully selected pieces of pinkish-brown agate, emulating the colouring, coat and shiny hooves of the animals. Between 1908 and 1911 Queen Alexandra purchased six pigs of varying models from Fabergé's London branch, including two in the form of cigar lighters – one of which is shown here made of aventurine quartz, and another of silver. During the same period King Edward VII purchased two models of pigs and Princess Victoria one. There are nineteen Fabergé pigs or piglets in the Royal Collection today, of which several were acquired as part of the Sandringham commission (shown on previous page).

COCKEREL

c. 1908

An example of what François Birbaum, one of Fabergé's designers, referred to as 'mosaic sculpture', this highly realistic sculpture is a combination of obsidian (tail and body) with agate feathers speckled with white highlights and is completed by a purpurine comb and rose diamond eyes.

Obsidian, agate, purpurine, rose diamonds, gold
Mark of Henrik Wigström;
gold mark of 73 zolotniks (1908–17)
5.3 x 4.5 x 2.1 cm
RCIN 40445

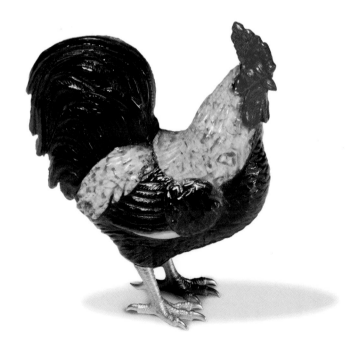

BANTAM COCKEREL

1908

Obsidian, purpurine, jasper,
rose diamonds, gold
Mark of Henrik Wigström;
gold mark of 72 zolotniks (1908–17)
9.9 x 7.8 x 4.7 cm
RCIN 40454

This large-scale model of a cockerel again uses obsidian to great effect – like most of the birds fitted with gold feet, it was made in Henrik Wigström's workshop. A plate from the album of designs produced in his workshop shows a drawing of a cockerel on a similar scale to this one, although it was apparently executed in different hardstones. In 1909 Queen Alexandra purchased a cockerel for the comparatively high sum of £113 10s. The large scale of this example may indicate that it was this cockerel that she purchased.

This breed of turkey was to be found only in East Anglia, and it is therefore indisputable that this remarkable sculpture was made as part of King Edward VII's 1907 commission. Surprisingly, another example of this model, of identical design and proportion, does exist in a private collection and was apparently not acquired by the royal family. The black obsidian perfectly captures the full body and feathers of the bird and is combined with purpurine, lapis lazuli and rose diamonds to represent the head of the creature. This model was purchased by the Prince of Wales (later King George V) from Fabergé's London branch in November 1909 for £55 and given to Queen Alexandra for her birthday on 1 December.

Obsidian, lapis lazuli, purpurine, rose diamonds, gold
Mark of Henrik Wigström; gold mark of 72 zolotniks (1908–17)
9.8 x 8.5 x 7.3 cm
RCIN 40446

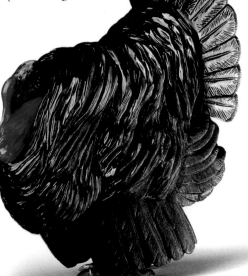

COCKERELS

c. 1908

LEFT: Agate, rose diamonds, gold
5.2 x 5.6 x 2.4 cm
RCIN 40447

RIGHT: Agate, cabochon rubies, gold
4.5 x 3.6 x 1.7 cm
RCIN 40305

Both of these cockerels are made of agate with gold legs and feet, but the one on the left has rose diamonds for eyes, while the one on the right has cabochon rubies.

There are no fewer than ten hens in the royal collection of Fabergé animals. On the left is one of the finest examples of the use by Fabergé of hardstones – the piece of agate selected is mid-reddish brown with a milky white striation that perfectly captures the sheen of the hen's feathers. Birbaum stated that the Sandringham carvings were generally made from naturalistically coloured stones that matched the colouring of the animal or bird – while this is perhaps not always the case, this hen is an excellent example of what he asserted. In contrast, the hen on the right is made entirely of purpurine with olivine eyes and gold legs that are fitted with springs.

LEFT: Agate, rose diamonds, gold
5.9 x 5.7 x 2.9 cm
RCIN 40450

RIGHT: Purpurine, olivines, gold
4.5 x 4.2 x 2.1 cm
RCIN 40007

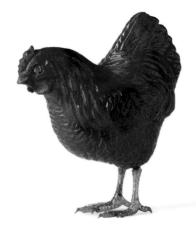

HENS

*c.*1908

LEFT: Agate, rose diamonds, gold
1.9 x 2 x 1.9 cm
RCIN 40134

RIGHT: Agate, cabochon rubies, gold
2.3 x 2.5 x 1.3 cm
RCIN 40062

The ledgers of Fabergé's London branch reveal that Queen Alexandra purchased three 'chickens', all of chalcedony with gold feet, at a cost of £8 15s each. The relatively small sum paid may indicate that they were on a small scale. Although there are two miniature Fabergé hens among those in the Royal Collection, it is difficult to make a specific identification; the 'chickens' were possibly purchased as presents and may no longer be in the Royal Collection.

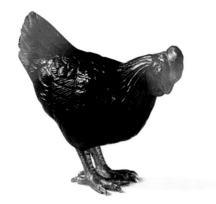

The ducks in the Royal Collection are carved from either aventurine quartz, cornelian or pale white chalcedony, as with these two examples.

LEFT:
Chalcedony, cabochon rubies, gold
4.8 X 4.9 X 2.6 CM
RCIN 40326

RIGHT:
Chalcedony, cabochon rubies, gold
3 X 4 X 1.6 CM
RCIN 40281

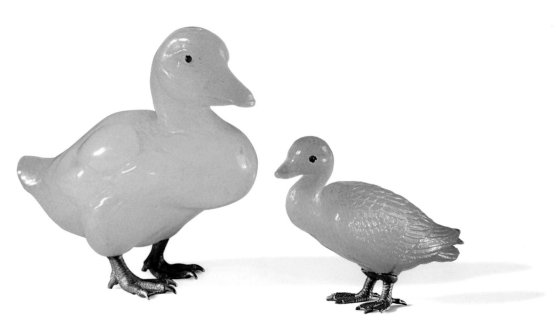

DUCKLINGS

*c.*1908

LEFT TO RIGHT:
Aventurine quartz, rose diamonds, gold
Mark of Henrik Wigström;
gold mark of 72 zolotniks (1908–17)
6 x 4.4 x 5 cm
RCIN 40419

Aventurine quartz, olivines, gold
6.9 x 6.2 x 4.6 cm
RCIN 40397

Aventurine quartz, cabochon rubies
Mark of Henrik Wigström;
gold mark of 72 zolotniks (1908–17)
4.8 x 5.3 x 2.8 cm
RCIN 40468

These animal studies are of ducks or ducklings in yellow aventurine quartz – a stone Fabergé's sculptors evidently found successful for sculptures of ducks. While it lacks the naturalism of other hardstones selected to represent the true colouring of a particular animal, the animal sculptures themselves are very carefully observed. In the Royal Collection there are a total of four models of ducks in aventurine quartz made in Wigström's workshop, three of which are illustrated here.

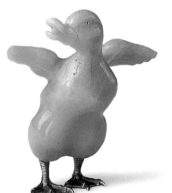

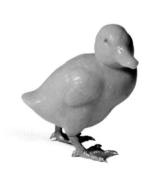

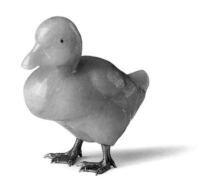

Of cornelian with ruby eyes, this model is one of eight ducks modelled as part of the Sandringham commission. Four were purchased by members of the royal family from Fabergé's London branch between 1907 and 1916. This is believed to be the duck purchased by Queen Alexandra from Fabergé's London branch in 1909 at a cost of £11 15s.

Cornelian, cabochon rubies, gold
Mark of Henrik Wigström;
gold mark of 72 zolotniks (1908–17)
3.4 x 3.3 x 2.2 cm
RCIN 40328

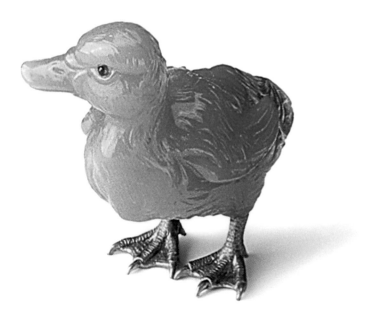

GEESE

1908, 1911

The design for this goose – exactly as executed, with the date 1911 – appears in the album from the workshop of Henrik Wigström. The sculpture is executed in a combination of white quartzite and black obsidian, to which a cornelian beak and gold feet have been added. The sculpture is finished with rose diamond eyes.

Plate III from an album of watercolour designs from the workshop of Henrik Wigström showing the goose (pictured right).

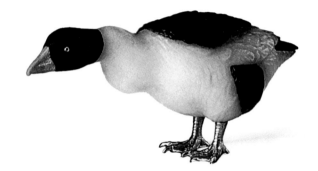

An identical combination of stones is employed for this model of a goose as for the previous example, but this time the pose is more upright. The model was similarly made in Wigström's workshop. This goose was purchased from Fabergé's London branch by Queen Alexandra on 13 November 1911 for £16.

FACING PAGE:
Quartzite, obsidian,
rose diamonds, gold, cornelian
Mark of Henrik Wigström;
gold mark of 72 zolotniks (1908–17)
3 x 7 x 2.3 cm
RCIN 40323

BELOW LEFT:
Quartzite, obsidian, rose diamonds, gold
Mark of Henrik Wigström;
gold mark of 72 zolotniks (1908–17)
English import marks for 1908
5.5 x 5.6 x 3 cm
RCIN 40340

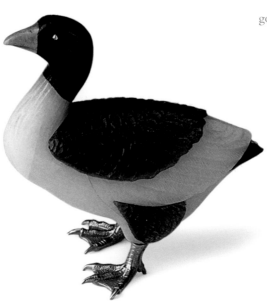

AFRICAN GOOSE

*c.*1908

Chalcedony, cabochon rubies, gold
10.3 x 9 x 4.5 cm
RCIN 40469

This large-scale portrait model is carefully observed and almost certainly modelled from nature.

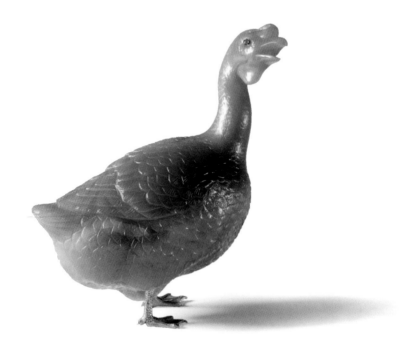

There are six examples of pigeons and doves in the collection of Fabergé items. Four are included here. Both King Edward VII and the Prince of Wales (later King George V) kept homing pigeons at Sandringham next to Queen Alexandra's dove-house. According to contemporary accounts, most of the pigeons were of famous Belgian breeds. 40032 is of banded grey agate with ruby eyes, 40398 is of chalcedony with ruby eyes and the pouter pigeon, 40467, is of brown agate with rose diamond eyes. They all have the customary gold feet but are unmarked.

George V and Queen Mary with
a wicker box of pigeons, 1927.
RCIN 2925994

LEFT: Agate, rose diamonds, gold

3 X 4.2 X 2.1 cm

RCIN 40467

RIGHT: Chalcedony, cabochon rubies, gold

4.3 X 4.6 X 2.2 cm

RCIN 40398

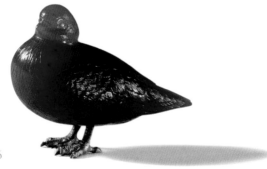

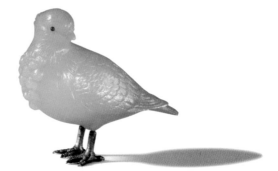

LEFT: Banded agate, cabochon, rubies, gold
4.4 x 5 x 2 cm
RCIN 40032

RIGHT: Chalcedony, rose diamonds, gold
4.7 x 4.1 x 3.3 cm
RCIN 40448

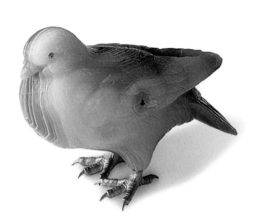

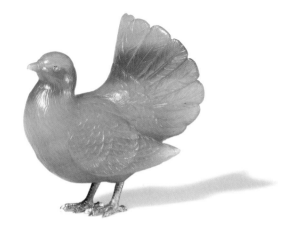

CAGED BIRDS

*c.*1908

Contemporary photographs show that several caged birds were kept at Sandringham House. A view of the Princess of Wales's Dressing Room dated 1882 shows that she kept there both a caged bird and a parrot or cockatoo on a perch, while a photograph of the Saloon in 1889 shows a bird-cage containing a cockatoo. It was well known that Queen Alexandra had a liking for parrots, but apparently she was rather overwhelmed when a friend presented her with no fewer than forty of these birds. While similar examples of birds on perches or in cages are known to have been produced by Fabergé, it is easy to see how these exquisite sculptures would have appealed to the King and Queen.

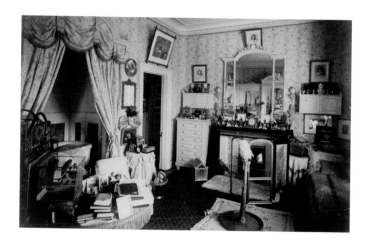

Parrot on a perch
Agate, rose diamonds, gold, silver-gilt,
guilloché enamel
Mark of Michael Perchin;
silver mark of 88 zolotniks (1896–1908)
FABERGÉ in Cyrillic characters
14.5 x 7.2 x 6.2 cm
RCIN 40481

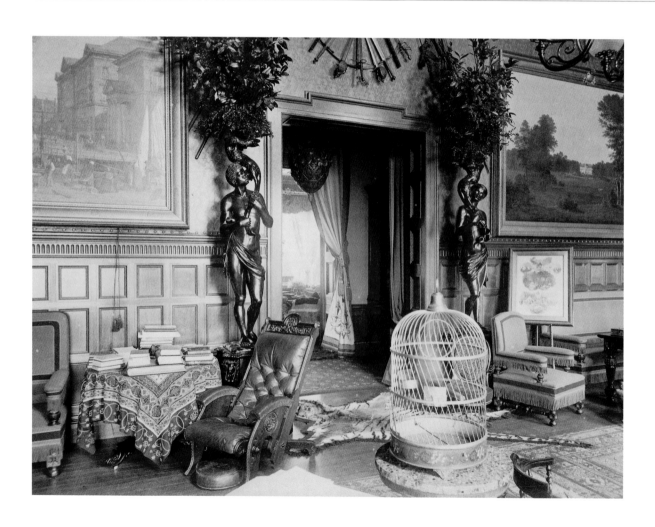

LEFT: Cockatoo on a perch
Agate, rose diamonds, gold
Mark of Michael Perchin;
gold mark of 56 zolotniks (before 1896);
FABERGÉ in Cyrillic characters
14.5 x 7.2 x 6.2 cm
RCIN 40481

RIGHT: Cockatoo in a cage
Tiger's eye quartz, rose diamonds,
gold, silver-gilt
Mark of Michael Perchin;
silver mark of 88 zolotniks (1896–1908);
FABERGÉ in Cyrillic characters
10.4 x 7.1 cm
RCIN 40480

THE ESTATE

PHEASANT

*c.*1907

Agate, rose diamonds, gold
3.3 x 6.2 x 2.1 cm
RCIN 40314

PREVIOUS PAGE: A shooting party on the estate, November 1907.
RCIN 2303276

The importance of Sandringham as a sporting estate has already been mentioned (see p. 44). According to the account of Boris Frödman-Cluzel, he and the other sculptors were invited to spend a day shooting with the King. This model was probably produced from life as part of the commission.

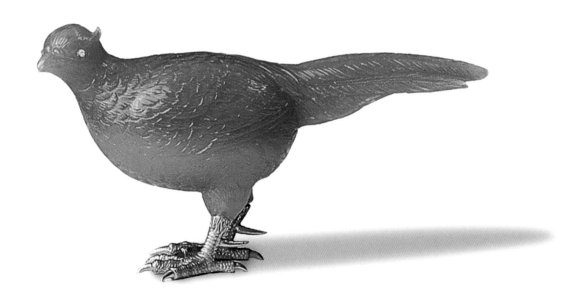

Obsidian, quartzite, rose diamonds, gold
2.5 x 6.4 x 1.6 cm
RCIN 40286

This carefully observed carving of a swallow replicates the distinctive markings of the bird in obsidian and white quartzite.

CROW

*c.*1907

Kalgan jasper, obsidian, aquamarine, silver-gilt
Mark of Henrik Wigström; silver mark of
88 zolotniks, undated
7.8 x 15.7 x 5.7 cm
RCIN 13756

This magnificent carving is on a far larger scale than all the other animals that formed part of the Sandringham commission, and although it was not purchased until 1914 (by Queen Alexandra) the extraordinarily well-observed portrait suggests that it was almost certainly modelled from life. The body of the bird is made from a combination of kalgan jasper and obsidian and is an example of what Birbaum described as 'mosaic sculpture' – when two or more stones are combined to give the most realistic effect possible, rather than relying purely on the striations naturally occurring within a single piece. The scale and quality of the piece is reflected in the high purchase price of £75.

GROUP OF RABBITS

*c.*1907

Agate, rose diamonds
4.6 x 8.4 x 6.7 cm
RCIN 40409

Fabergé produced a number of charming animal groups, several of which are represented in the Royal Collection (including monkeys and piglets). The doe and three baby rabbits are carved from a single piece of agate and their eyes are set with rose diamonds. This model was purchased from the London branch by Grand Duchess Vladimir of Russia (1854–1920) on 20 November 1913 and was presumably given to Queen Alexandra for her birthday (1 December).

RABBITS

c.1907

Two charming and naturalistic portraits of rabbits in characteristic poses. One is sitting up on its haunches, the other in a recumbent position.

LEFT: Chalcedony, rose diamonds
2.2 x 3.8 x 2.2 cm
RCIN 40065

RIGHT: Chalcedony, cabochon rubies
5.1 x 3.5 x 2.4 cm
RCIN 40417

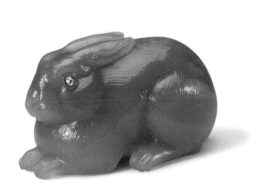

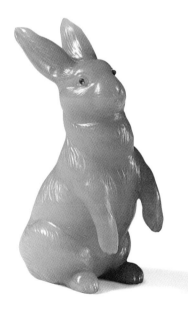

HARES

1907

LEFT: Chalcedony, rose diamonds
1.5 x 3.5 x 1.5 cm
RCIN 40092

RIGHT: Agate, rose diamonds
4.5 x 3 x 2 cm
RCIN 40069

Translating the typical characteristics of an animal into hardstone to achieve the most realistic representation was usually the primary concern of Fabergé's sculptors, and it explains why his animals have both freshness and enduring charm. Although previously recorded as rabbits, these particular carvings have more the proportions of hares. In total there are nineteen rabbits and two hares in the Royal Collection.

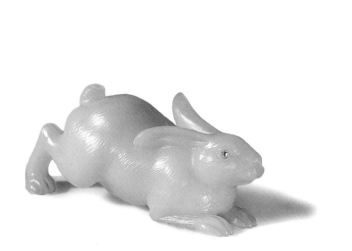
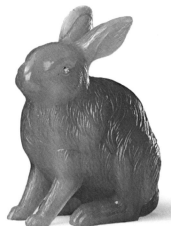

There are eight rats and mice in the Royal Collection, most of which are of hardstone set with diamond-encrusted tails and ears. These objects, while less realistic than many of the other Sandringham animals, would nonetheless have had their place among the creatures encountered by Fabergé's sculptors on the estate.

LEFT:
Chalcedony, rose diamonds, silver
2.2 x 4.6 x 2 cm
RCIN 40056

RIGHT:
Chalcedony, rose diamonds, silver
2.2 x 4.6 x 2 cm
RCIN 40013

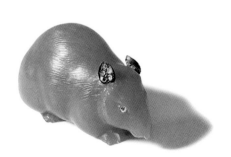

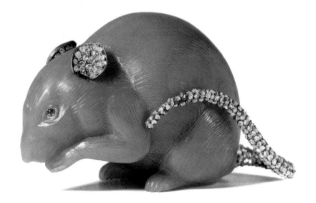

MOUSE

*c.*1907

Agate, rose diamonds, silver
2.5 x 3.8 x 2.2 cm
RCIN 40045

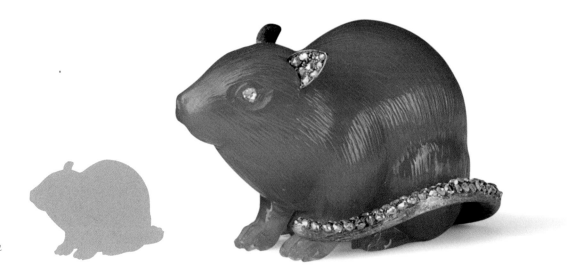

Agate, rose diamonds
2.5 x 3.9 x 1.7 cm
RCIN 40301

It seems that a pair of bears was kept on the Sandringham estate as late as the 1880s. Mrs Herbert Jones described how 'two big bears in a pit, indifferent to spectators, calmly climb their accustomed pole'. According to Helen Cathcart, the bear pit was adjacent to York Cottage. It contained two bears called Charlie and Polly who 'were dreaded by their keeper when he had to wash them every day'. They were eventually moved to London Zoo by the Prince of Wales (later King George V).

DORMOUSE

*c.*1908

Chalcedony, platinum, gold,
cabochon sapphires
6.2 x 5.2 x 5.8 cm
RCIN 40261

A quintessential inhabitant of the English hedgerow is beautifully captured by Fabergé's sculptors in this portrait of a dormouse carefully holding gold straws, which he is nibbling beneath his platinum whiskers. Queen Alexandra purchased this model from the London branch on 5 November 1912 at a cost of £33. It was subsequently referred to as 'Queen Alexandra's Dormouse' in all records of the collection.

STOAT

*c.*1907

Opal, cabochon rubies
1 x 2.7 x 1 cm
RCIN 40095

Included among the many animal sculptures by Fabergé in the Royal Collection are a number of miniature pieces. These are prime examples of the extraordinary attention to detail of Fabergé's craftsmen, even on a tiny scale. This example of a stoat is typically English and is believed to have formed part of the Sandringham commission.

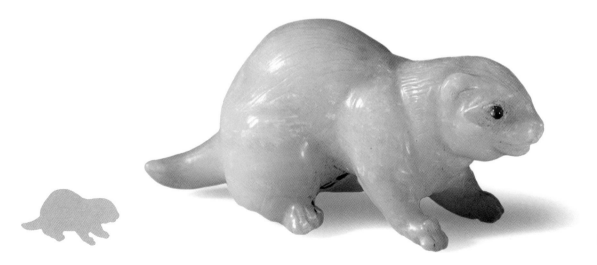

GLOSSARY

Agate	A form of chalcedony in which iron oxide causes varying shades of brown
Aquamarine	A blue-green variety of the mineral beryl
Aventurine quartz	A quartz containing mica, iron oxides or pyrite crystals which give it a range of colours
Bowenite	A pale green serpentine named after its discoverer, G. T. Bowen
Cabochon	Dome-shaped unfaceted stone
Chalcedony	A fine-grained mineral of silicic acid, usually of a white or milky hue
Cornelian	A variety of chalcedony, usually a warm orange colour
Diamond	Brilliant: circular-cut with a flat top
	Rose: the top cut into triangular facets
Enamel	A glass capable of being fused to metal
Fluorspar	A halide mineral which exists in a wide range of colours
Jasper	An opaque chalcedony ranging from brown to green in colour
Lapis lazuli	A dark blue stone with gold deposits, found in Siberia
Magnesite	A white or gray mineral, also tinted yellow or brown
Nephrite	A dark green jade found in Siberia
Obsidian	A dark grey or black volcanic glass found in Siberia
Olivine	A pale green mineral, also called peridot
Purpurine	A dark red, man-made, vitreous substance first produced in the seventeenth century and introduced to Russia by the Imperial Glass Factory. Reinvented by Fabergé and his contemporaries
Quartzite	A form of quartz
Tiger's eye quartz	A chatoyant gemstone of golden to red-brown colour

Gold is measured in 56 and 72 zolotniks, the equivalent to 14 and 18 carats
Silver is measured in 84, 88 and 91 zolotniks, the equivalent to 21, 22 and 22 ¾ carats

BIBLIOGRAPHY

PUBLISHED SOURCES

G. Battiscombe, *Queen Alexandra*, London 1969

H.C. Bainbridge, *Twice Seven. The Autobiography*, London 1933

H.C. Bainbridge, Fabergé Animals at Sandringham, *Country Life*, 20 November 1942

H.C. Bainbridge, *Peter Carl Fabergé. His Life and Work 1846–1920*, London 1949

H. Cathcart, *Sandringham, The Story of a Royal Home*, London 1964

W.A. Dutt, *The King's Homeland, Sandringham and North West Norfolk,* London 1904

A. Fitzgerald, *Royal Thoroughbreds. A History of the Royal Studs,* London 1990

C. de Guitaut, *Fabergé in the Royal Collection*, London 2003

G. von Habsburg and M. Lopato, *Fabergé Imperial Jeweller,* Washington 1993

S. Holland, Viscount Knutsford, *In Black and White*, London 1926

H. Jones, *A Guide to Sandringham Past and Present*, London 1883

P. Magnus, *King Edward the Seventh*, London 1964

K. McCarthy, Fabergé in London, *Apollo*, July 2006

T. Muntian, The Kremlin Collection of the Empress's Personal Belongings, in *Marie Feodorovna Empress of Russia*, Copenhagen 1997

Nationalmuseum Stockholm, *Carl Fabergé Goldsmith to the Tsar*, 1997

F. Ponsonby, *Recollections of Three Reigns,* London 1951

V.V. Skurlov, Boris Frödman-Cluzel, Fabergé Firm Artist, in *Carl Fabergé Goldsmith to the Tsar,* ed. E. Welander-Berggren, Stockholm, 1997

A.K. Snowman, The English Royal Collection at Sandringham House, Norfolk, *Connoisseur,* June 1955

A.K. Snowman, *Goldsmith to the Imperial Court of Russia: Fabergé 1846–1920*, London 1977

U. Tillander-Godenhielm *et al*, *Golden Years of Fabergé: Drawings and Objects from the Wigström Workshop,* Paris, 2000

C. Vanderbilt Balsan, *The Glitter and the Gold*, London 1953

UNPUBLISHED SOURCES

RA – Royal Archives, Windsor Castle

INDEX

Published by Royal Collection Enterprises Ltd
St James's Palace, London SW1A 1JR

For a complete catalogue of current publications, please write to the address
above, or visit our website at www.royalcollection.org.uk
© 2010 Royal Collection Enterprises Ltd

Text and reproductions of all items in the Royal Collection and Royal
Archives © 2010 HM Queen Elizabeth II.

013376

ISBN 978 1 905686 12 4

British Library Cataloguing in Publication Data:
A catalogue record for this book is available from the British Library.

Designed by Paul Sloman
Production management by Debbie Wayment
Colour reproduction by Altaimage, London
Printed on 157gsm GS Chinese matt art
Printed and bound by C&C Offset Printing Co. Ltd

PICTURE CREDITS

All works reproduced are in the Royal Collection unless indicated below.
The Royal Collection is grateful for the permission to reproduce the
following: p.10, Hulton Archive/Getty Images; p.14 and p.15, Fersman
Mineralogical Museum; p.17 Courtesy of Valentin Skurlov; p.19 © The Beck
Collection; p.25, Wartski, London.

Every effort has been made to contact copyright holders; any omissions are
inadvertent and will be corrected in future editions if notification of the
amended credit is sent to the publisher in writing.

ACKNOWLEDGEMENTS

The permission of Her Majesty The Queen to reproduce items from the
Royal Collection and the Royal Archives is gratefully acknowledged.

I am immensely grateful to Her Majesty The Queen for giving me privileged
access to the Royal Collection and Royal Archives. In the preparation of this
book I am indebted to many colleagues both in the Royal Collection and
from outside for their assistance, including Graham Beck, Dominic Brown,
Nina Chang, Stephen Chapman, Jacky Colliss Harvey, Tatiana Fabergé, Lisa
Heighway, Katie Holyoak, Alice Milica Ilich, Jill Kelsey, Kieran McCarthy,
Geoffrey Munn, Daniel Partridge, Hugh Roberts, Valentin Skurlov, Paul
Sloman, Paul Stonell and Debbie Wayment.

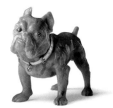

CHRONOLOGY OF THE HOUSE OF FABERGÉ

1814 Fabergé's father Gustav born of Huguenot origin in Pernau on the Baltic

1841–2 Gustav Fabergé becomes a master goldsmith in St Petersssburg and opens a shop at 12 Bolshaya Morskaya.
 He marries Charlotte Jungstedt

1846 Peter Carl Fabergé born in St Petersburg, 30 May

1860 Gustav Fabergé and his family move temporarily to Dresden

1861–4 Carl Fabergé travels through Europe as part of his apprenticeship in Frankfurt, Florence and Paris

1862 Fabergé's brother Agathon born in Dresden

1864 The Fabergé family return to St Petersburg and Carl Fabergé joins his father's business

1866 Gustav Fabergé starts to supply the Imperial Cabinet

1867 Carl Fabergé works voluntarily at the Hermitage Museum, repairing antiquities and acting as an appraiser of
 metalwork and jewellery acquisitions

1872 Carl Fabergé takes over his father's business. Fabergé marries Augusta Jakobs (1852–1925)

1874 Birth of son Eugene Fabergé (d.1960)

1876 Birth of son Agathon Fabergé (d.1951)

1877 Birth of son Alexander Fabergé (d.1952)

1882 Fabergé awarded the gold medal at the Pan-Russian Exhibition, Moscow. Carl's brother Agathon joins the firm.

1884 Birth of son Nicholas Fabergé (d.1939). All four sons later join the family firm

1885 Fabergé appointed Supplier to the Court of Tsar Alexander III. The Tsar commissions the first Imperial Easter
 Egg. Fabergé awarded a gold medal at the Nuremberg Fine Art Exhibition for his copies of the Scythian Treasure
 (discovered at Kerch in the Crimea in 1867)

1886 Michael Perchin (1860–1903) becomes head workmaster

1887 Fabergé's Moscow branch opens and is managed by Allan Bowe

1895 Death of Agathon Fabergé

1897 Carl Fabergé is awarded the royal warrant for the courts of Sweden and Norway

1900 Fabergé exhibits at the Exposition Universelle in Paris and is awarded the Grand Prix. He is decorated with the
 Légion d'Honneur. The Odessa branch of the firm is opened

1903 The London branch of the firm, managed by Arthur Bowe, is opened at Berners Hotel.
 Henrik Wigström (1862–1923) succeeds Michael Perchin as head workmaster

1904 The London branch moves to Portman House, Duke Street

1905 The Kiev branch of the firm is opened

1906 The London branch moves to 48 Dover Street

1907 H.C. Bainbridge takes over as manager (with Nicholas Fabergé) of the London branch

1908 Fabergé is appointed court jeweller and enameller to the King of Siam

1911 The London branch moves to 173 New Bond Street

1915 The London branch is closed

1918 Fabergé's St Petersburg headquarters is closed and he emigrates to Switzerland

1920 Carl Fabergé dies in La Rosiaz, Switzerland, 24 September